A MONTEREY
ALBUM
LIFE BY THE BAY

A
MONTEREY
ALBUM
LIFE BY THE BAY

Dennis Copeland and Jeanne McCombs

ARCADIA

Published by Arcadia Publishing,
an imprint of Tempus Publishing, Inc.

580 Howard Street, Suite 302
San Francisco, CA 94150

2 Cumberland Street
Charleston, SC 29401

With offices in Chicago, IL, and Portsmouth, NH

Printed in Great Britain.

Library of Congress Catalog Card Number: 2003105834

For all general information contact Arcadia Publishing at:
Telephone 843-853-2070
Fax 843-853-0044
E-Mail sales@arcadiapublishing.com

For customer service and orders:
Toll-Free 1-888-313-2665

Visit us on the internet at http://www.arcadiapublishing.com

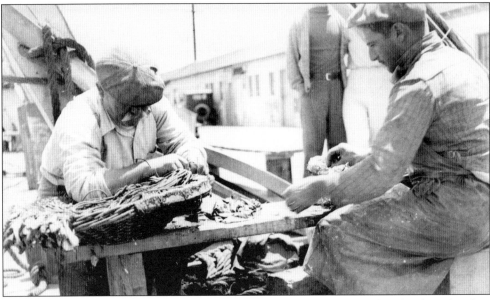

FISHERMEN LINE HOOKS ON FISHERMAN'S WHARF. Italian fishermen set their hooks on longline baskets for rockfish, lining up to 300 hooks on each basket. Ella Huglen took this snapshot in the summer of 1939 when her family lived in Richmond, California, and vacationed in Monterey. The scene reminded her of the fishermen in her own Norwegian family. The Huglens moved to Monterey in 1950. (Elizabeth Leeper, donor; Shades of Monterey Collection, No. 6000.)

CONTENTS

ACKNOWLEDGMENTS

We would first and foremost like to thank the many donors who contributed a photograph, a bit of memory, or a story associated with a photograph. We are very grateful to those residents who generously donated a family photograph for inclusion in the Shades of Monterey projects held in 1998 and 2000. Without them we would not have been able to start, much less complete this work. For this book, we could choose only 200 from among the over 800 photographs in that collection. We had to make many difficult selection decisions and, if at all possible, we would have included all of these unique and wonderful images.

The Shades of Monterey volunteers greatly advanced—and eased—the selection process by their diligent work in interviewing donors and initially choosing the best images. Our goal in the Shades project was to document everyday family and community life and these volunteers succeeded outstandingly.

Credit goes to some special people who encouraged, assisted, and persevered with our work on the book project. At the start there was Paula Simpson, director of the Monterey Public Library, whose constant support and assistance made this book possible. Her commitment strengthened our commitment and belief in this book.

Thanks as well to Janis Rodman, reference librarian and coordinator of the Shades of Monterey Photo Day projects. No one has understood better the importance of family photographs to our richly woven community history.

We could never have accomplished this project without the special bonus of time and additional information generously given by the following: Lee and Mamie Blaisdell, Toni Brucia, Jean Cordero, Evelyn Crumpley, Marcia DeVoe, the late Bonnie Gartshore, Edie and the late Sam Karas, Angela McCurry, Ann Prego, Dorothea Sallee, Millie Sanford, Merrie Thornburg, and Linda Yamane. They solved some mysteries and filled in many gaps.

We would like to especially acknowledge the help of Tim Thomas, historian and director of programs at the Maritime Museum of Monterey, for reviewing and adding valuable comments about the maritime photographs.

We want to thank California History Room volunteers Lucinda Boone and Shirley Ray for carefully copying and filing photographs. We also wish to express our gratitude for the photographic wizardry of Gary Russell and the staff of the GMR Custom Photographic Lab, who expertly scanned and digitized our photos.

Finally, we would like to thank Keith Ulrich of Arcadia, who initiated the book project, and special thanks to our Arcadia publisher, Christine Riley, and Sarah Wassell, production editor, for their patience and enthusiasm to see this project to fruition.

INTRODUCTION

Early on we established a set of criteria for this book: the focus of the photographs must be on the people of Monterey and, wherever possible, on people engaged in everyday activities.

The core of our project remains the Shades of Monterey photo days and the resulting collection of photographs donated by Monterey area residents. Two Shades of Monterey photo days have been held at the Monterey Public Library, and they have provided one of the richest veins of Monterey's gold, representing the most vibrant record of Monterey's community and family life. Along with selections from the library's other historical photograph collections, such as the Harbick, Morgan, and the Historical Photograph File collections, we deliberately set out with the Shades photos to document not the historic buildings and landmarks of Monterey, but Monterey's residents and visitors over time. Sifting through thousands upon thousands of images, we finally had to narrow the field to a select, representative number, fitting the limits of the book's length and our own unflagging efforts to complete this work.

Monterey is a truly beautiful natural and cultural environment. It is the people of Monterey, however, who tell its story most vividly. Through snapshots and family albums, Monterey residents retell their own histories, personally and communally, in work, play, and celebration. This is what makes this book a Monterey album of life by the bay.

Monterey's heritage has many facets. The place itself is a mixture of nooks, hills, and spectacular views of Monterey Bay. It has been called California's first capital, a town steeped in traditions of adobe and fandango, and the sardine capital of the world. Its principal historical resort, the luxurious Hotel del Monte, was once known as the "Queen of American watering places." The people and communities who settled Monterey echo its varied land and seascape. Its diverse historic patterns are reflected in its human face, its cultural celebrations, and historical memory.

Since Monterey's first residents, the Rumsien, encountered Spanish colonists two and a half centuries ago, succeeding immigrants have brought distinctive and rich folkways. Each settled in a physical niche on the coast and wove their social and cultural patterns within the Monterey tapestry. Rumsien, Spanish, Mexican, British, Irish, French, Portuguese, Chinese, Italian, Japanese, Scandinavian, and many others settled to carve out a livelihood by the bay and upon its waters.

In all, these photographs show Monterey's people engaged in their everyday lives. It shows how they saw themselves and others in a moment of time. The photographs also reveal the customs, styles, and events of the community close at hand. Each tells a story. Sometimes a photo reveals more than the photographer may have realized. And sometimes some small detail—perhaps a hat, an expression, a pose, or setting—offers a clue to an event, a story, a life. Through all the varied photos of people and their activities, we also see Monterey mirrored as it rejoiced, worked, and grew.

Finally, photographs are uniquely visual artifacts. They immediately document the past, but a past which was momentary present, that was deliberately captured for the viewers—family, friends, colleagues, or neighbors—to recall and reassemble what life was once like. *A Monterey Album* is our tribute to those captured memories of Monterey's people.

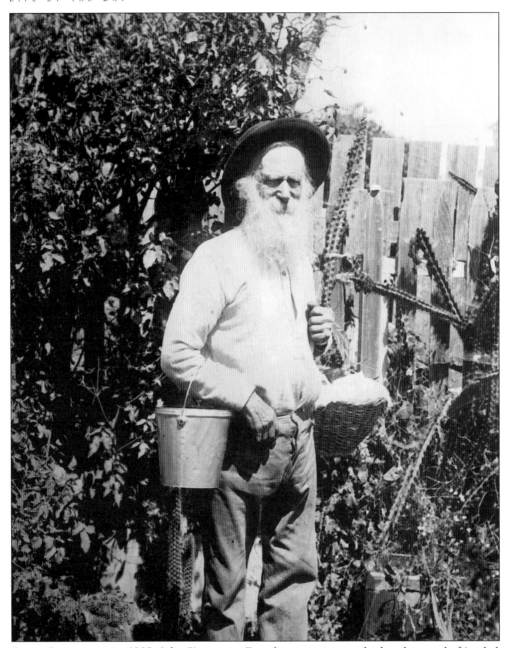

JULES SIMONEAU, C. 1899. Jules Simoneau, French restaurateur and saloonkeeper, befriended the young writer Robert Louis Stevenson when Stevenson visited Monterey in 1879. Simoneau's restaurant, located across from the Cooper-Molera House, is now the site of the present-day transit center, named Simoneau Plaza in his honor. Later in life, Simoneau kept in close contact with his friends and neighbors by packing his homemade tamales in a wicker basket and selling them door-to-door. (J.K. Oliver, photographer; Historic Photo No. 4647.)

On the Job

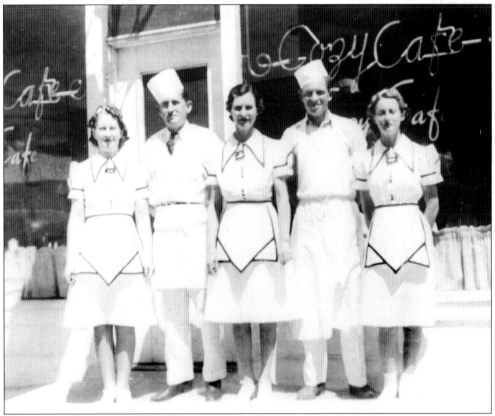

The Cozy Café. Members of the Thornburg family staffed the Cozy Café, located downtown at 445 Tyler Street, in 1941. From left to right are Luella, Sam (proprietor), Delia (Sam's wife), Edward, and Edith. In 1946 the café featured "home made breads, muffins, Southern fried chicken and steaks," specialties of chef Delfin Rondari, formerly of the Blue Ox Club and Mission Ranch. (Merrie Thornburg, donor; Shades of Monterey Collection, No. 6804.)

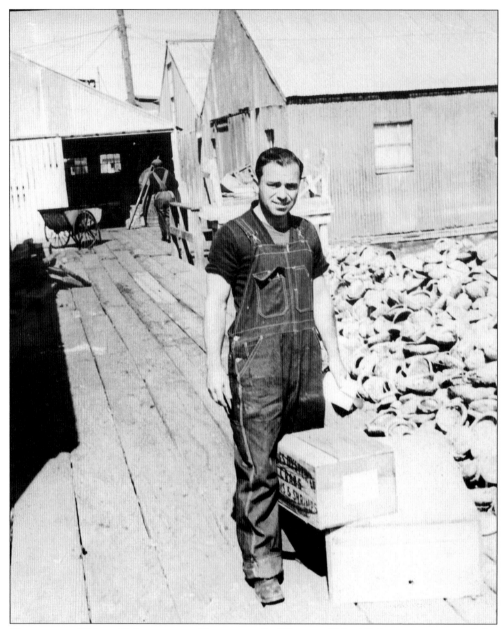

COTTARDO "MONK" LOERO ON FISHERMAN'S WHARF. "Monk" Loero, manager of the General Fish Company on Municipal Wharf #2, is seen in this 1940 photograph. The huge accumulation of abalone shells is testament to the once abundant abalone harvest in Monterey. A typical summer's catch in the 1930s would bring in 200 dozen abalone from a three-day trip. When "Monk" was a small child, his Italian family moved from San Francisco to Santa Cruz right after the 1906 earthquake. In 1936 he moved to Monterey and worked in the International Fish Company on Fisherman's Wharf. "Monk" lived with his wife, Irene, and daughter Carolyn at 1180 Franklin Street. "Monk" was so dedicated to his work that when a shipment of fish came in on his daughter's wedding day, he and the groom's father went down to the Wharf in their tuxedos to unload it. (Gary Carlsen, donor; Shades of Monterey Collection, No. 6400.)

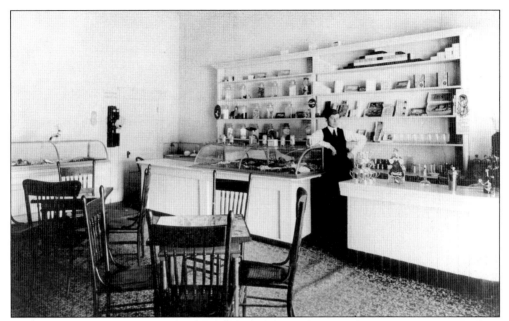

ELSEN'S CANDY STORE. Confectioner Edward Elsen is seen here inside his candy and ice cream parlor located at 318 Alvarado Street, about 1910. Elsen was born in Kenosha, Wisconsin, and came to Monterey with his parents. Edward and his wife, Philomena, were married in 1914 and lived in a house they built at 159 Carmelito Street. (Marie McCrary, donor; Shades of Monterey Collection, No. 6452.)

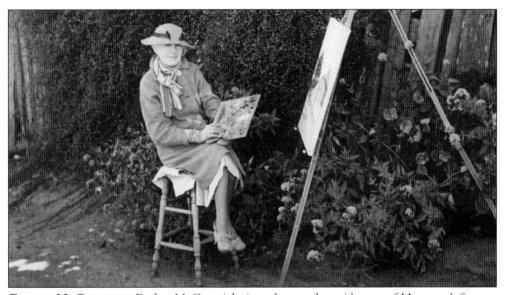

EVELYN McCORMICK. Evelyn McCormick sits at her easel outside one of Monterey's famous adobe houses in June 1939. A gifted artist, McCormick lived and worked on the Monterey Peninsula for over 50 years. Her first studio was on the second floor of the Custom House. She remembered well the dinners, banquets, and balls where she met poet George Sterling, painter Xavier Martinez, and other artists. She is well known for her colorful paintings of historic adobe buildings of Monterey. (Historic Photo No. 1590.)

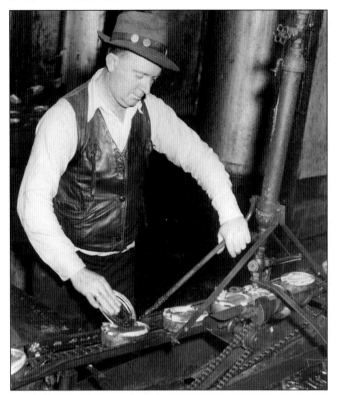

"SPIKING" THE SARDINE CANS, C. 1940. This cannery worker—notice the union buttons on his hat— adds a bit of hot sauce to sardines. Al DeRome, a former cannery worker, described how "in the wee hours of morning we ran a few of the best fish through my cooker, in one pound oval cans, like an Army mess kit. At a lidding machine, we could get a shot of tomato sauce." He recalled how "steam condensed above the cookers and trickled down onto our shirts. . . . Machinery turned the cans upside down, drained out the fish oil and replaced it with vegetable oil. A cloud, a haze, a mist of fish oil condensed in our hair." (Rey Ruppel, photographer; Historic Photo No. 4142.)

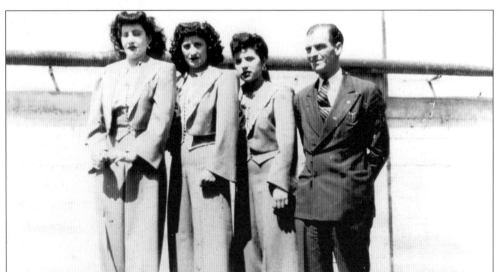

RIO THEATRE STAFF. From left to right are usherettes Julie Salas and Josie Delgadillo, head usherette Virginia Alvarado, and theatre manager Bill Souther, posed in the back of the Rio Theatre (which later became the Regency) on Alvarado Street in downtown Monterey. A year after this 1947 photograph was taken, Virginia married Daniel Lucero and went to work at the Xavier Cannery. Virginia is the sister of Phil Alvarado and a descendent of Governor Juan Bautista Alvarado. Josie Delgadillo (married name Esquivel) now lives in Pacific Grove. She and Virginia remain very good friends. (Maryon Alvarado, donor; Shades of Monterey II Collection, No. 6903.)

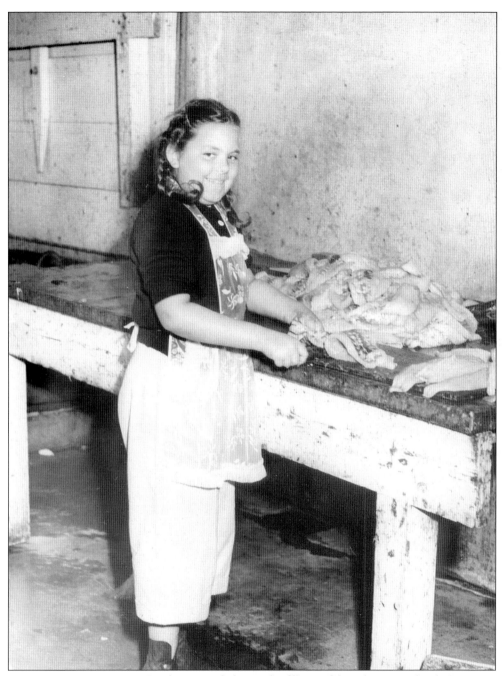

CAROLYN LOERO. Young Carolyn Loero helps out by filleting fish at the General Fish Company in the summer of 1949. Her father was manager of the company. Carolyn's first immigrant ancestor on her mother's side came to Monterey from New Spain (Mexico) in 1774. Ensuing ancestors were born in Monterey and married into Italian Swiss, French, and Italian immigrant families. Beginning with her Spanish ancestors who lived within the old Presidio walls and then on ranchos, six generations of her family have lived in Monterey. (Carolyn Loero Carlsen, donor; Shades of Monterey Collection, No. 6403.)

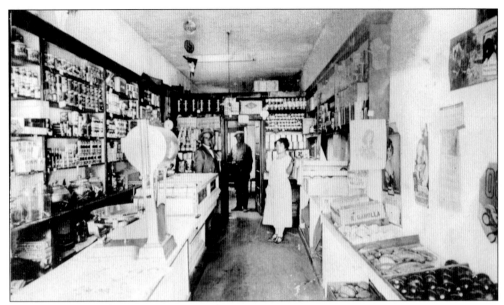

MAROTTA'S GROCERY STORE. The interior of Giuseppe Marotta's grocery store is seen here in the 1920s. The store was located next to J.K. Oliver's art studio on lower Alvarado Street near the Custom House. The Marotta family arrived in Monterey in 1918, and its members included a number of prominent local musicians. The store was transferred to Guiseppe's daughter Mary Marotta DeMaria and later to Giuseppe's younger daughter Emma. According to Mary's granddaughter, who donated this photograph, wine was sold from the back door of the store during Prohibition. (Laurie Hambaro, donor; Shades of Monterey Collection, No. 6054.)

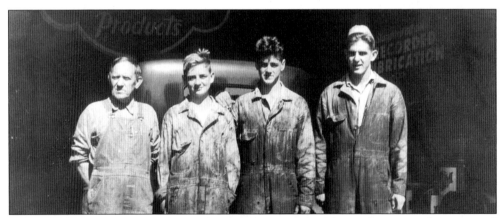

MONTEREY GARAGE. From left to right are Mert Conger and his nephews Darrell, Bruce, and Leland Petersen, all employees of the Monterey Garage in 1940. The business included a service station and garage providing auto repairs, auto sales, storage, and towing. The Monterey Garage was established in 1915 by W.E. Spoon. Mr. Spoon's eldest daughter, Lucile, worked as bookkeeper for the business, and in 1923 she married Edward C. Petersen, who had been manager of the garage since 1921. In 1930 the Petersens purchased the garage and raised three sons, Darrell, Bruce, and Leland. When World War II broke out, the sons worked at the garage until their draft notices came. Darrell and Bruce remained in the family business until it was sold in 1984. Leland became a mail carrier for the U.S. Postal Service in Monterey. (Leland Peterson, donor; Shades of Monterey II Collection, No. 6967.)

SOO TIN ON FISHERMAN'S WHARF.
Soo Tin, the good-natured co-owner
of the American Fish Market on
Fisherman's Wharf, is seen here in a
1936 photograph taken by Andy Prego,
who worked for Coca Cola and made
regular deliveries to the Wharf. Soo
Tin surprised Wharf habitués in 1938
by selling his share of the business to his
partner, Steve Genovese, after
threatening to retire for 20 years. (Ann
Prego, donor; Shades of Monterey
Collection II, No. 6300.)

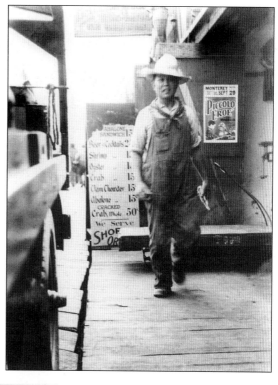

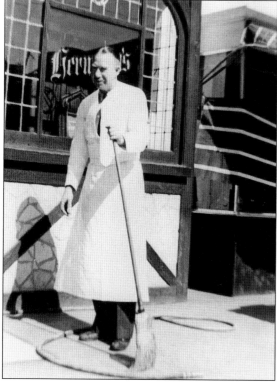

**HAROLD MACLEAN, "JACK OF ALL
TRADES."** Harold MacLean,
proprietor of Herrmann's Inn, sweeps
up in front of his popular restaurant
and tavern located at 380 Alvarado
Street in this 1940s photograph. In
1920, Herrmann's was located in the
house built by Jacinto Rodriguez (one
of the signers of the 1849 California
constitution) and later the home of
Port collector, Antonio Osio.
MacLean owned the establishment
from 1931 until 1957. He was a
business and civic leader who was
president of the chamber of commerce
in the mid-1940s and served on the
local school board. MacLean was
active in the Monterey Rotary Club,
sang in a barbershop quartet, and
helped organize the annual
Washington's Birthday Swim in 1929.
He was married to Joy Anthony,
daughter of J.C. Anthony, well-known
local builder. (Jan MacLean Jones,
donor; Shades of Monterey II
Collection, No. 6138.)

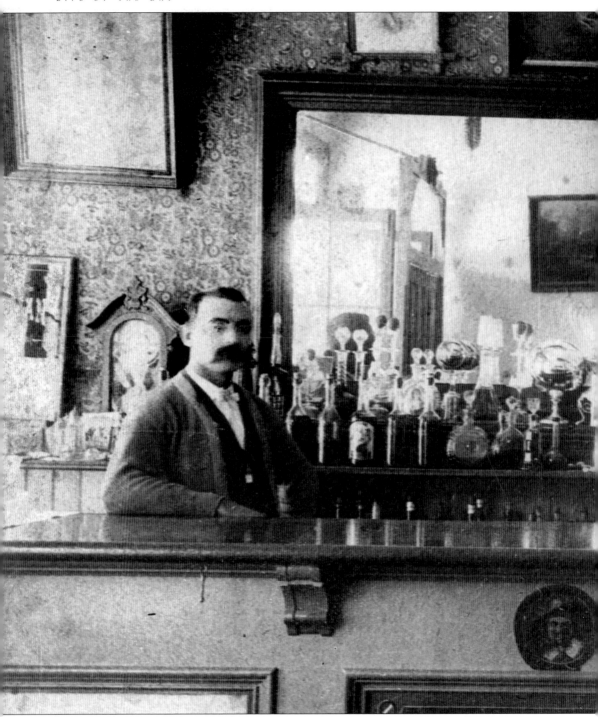

THE SANCHEZ BROTHERS AT THE BAR ON ALVARADO STREET. Adolpho Sanchez (right) and his brother Alexander (left) operated the saloon from 1882 until 1891, when they sold it to Manuel Diaz and Thomas Watson. The Sanchezes were members of an old Monterey family and owned a cattle ranch near Mission San Carlos (Carmel). According to one story, artists

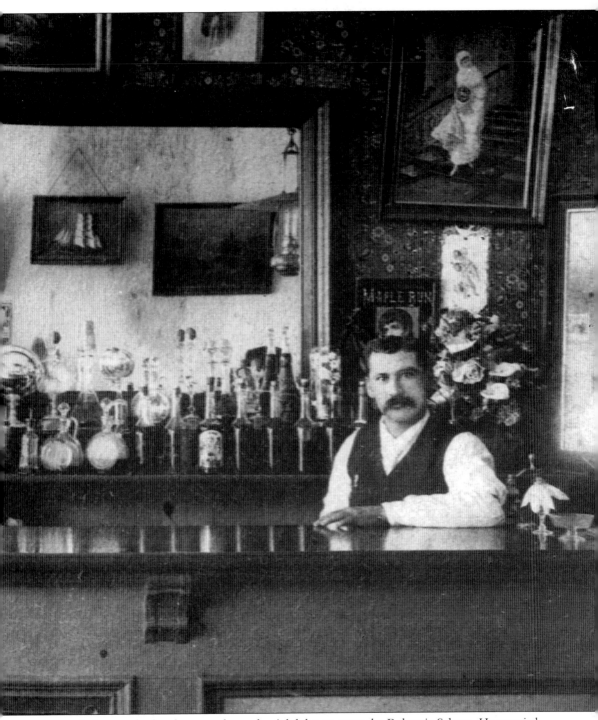

prevailed upon the handsome and popular Adolpho to open the Bohemia Saloon. He married Robert Louis Stevenson's sister-in-law, Nellie Van de Grift, who later wrote several books on California history. (Historic Photo No. 5064.)

THE BLAIR SISTERS. Artists Barbara and Virginia Blair take a break from work in their Fisherman's Wharf studio (site of the current Wharf Theater) in 1947. Barbara, who studied pottery at University of California, Los Angeles, and Virginia, who pursued painting and design at the Art Institute of Chicago, pooled their talents and established a ceramics business featuring jewelry and pottery. The following year, Barbara married painter Gerald Wasserman. (Fred Harbick, photographer; Harbick Collection.)

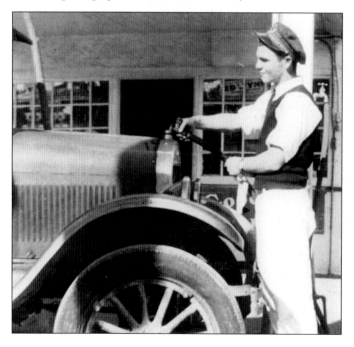

CLARENCE "AL" ALLEN. Clarence "Al" Allen works at his Texaco service station on the corner of Scott and Pacific near the Whaling Station in 1929. As postman on the Del Monte Express train, Allen's father would have the mail sorted from Monterey by the time he arrived in San Francisco. Al was a Monterey Sea Scout. Interested in all things seaworthy, he enlisted in the Navy and became a chief petty officer in 1939. He was commissioned ensign during a battle in the Pacific in 1942. (Marcia Frisbee DeVoe, donor; Historic Photo File No. 3727.)

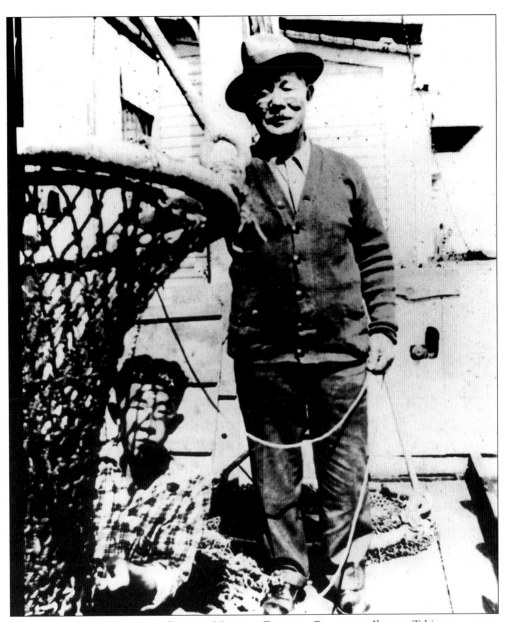

FISHERMEN WITH HOIST AT PACIFIC MUTUAL FISHING COMPANY. Ikutaro Takigawa, owner of the Pacific Mutual Wholesale Fishing Company (standing), is depicted in this 1934 photo with his grandson Kiyoshi Takigawa. Pacific Mutual, founded around 1915, was the largest fish business in Monterey during the 1930s and 1940s. During the period prior to World War II, Japanese and Italians dominated Monterey's diverse fishing community of boat owners, fishermen, canners, wholesalers, and retailers. Prior to 1942, Japanese were owners and operators of over half of the businesses on the Wharf. (William Takigawa, donor; Shades of Monterey II Collection, No. 6334.)

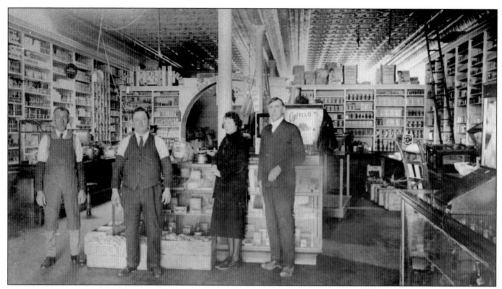

STRAUB'S GROCERY. Inside Straub's Grocery store, located at 314 Alvarado in the 1920s, are Mr. Ingel (left), a clerk, and George F. Straub (right), owner of the market, who lived at 318 Larkin with his wife, Albertina. Straub's proudly advertised "Quality groceries in a clean store—handled in a sanitary manner." To Mr. Straub's left is Fay Baugh, who played the piano for the silent movies at the nearby Golden State Theater. (Ann Quattlebaum, donor; Shades of Monterey Collection, No. 6821.)

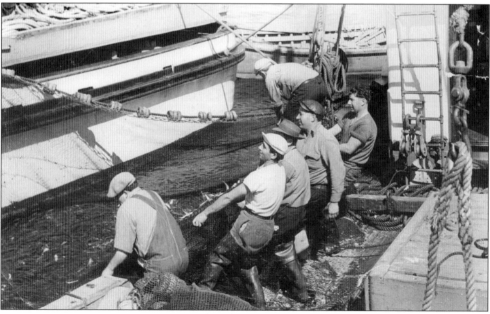

PURSE SEINER CREW. The years from 1939 to 1942 were "record" years for sardine catches at Monterey. In 1941, Monterey's fleet of 75 purse seiners brought in over 248,000 tons of sardines valued at over $4 million. In this 1940–1941 photo, the crew of the *City of Monterey* keeps the net taut while they transfer the sardines from the filled-to-capacity boat, the *California Rose*, to the *City of Monterey*. (Historic Photo No. 4145.)

SISTER JOSEPH. Sister Joseph, Order of St. Francis, born in 1874 in Germany, was a nun at the convent of San Carlos Church. Sister Joseph taught seventh and eighth grades at San Carlos School. She is remembered by this photograph's donor, Marie McCrary, as a rather strict teacher but with a good sense of humor. When one of her students made a mistake, she'd say, "You little silly goosey." She was also the Mother Superior's "second in command." This photograph was taken during eighth-grade graduation in June 1935. (Marie McCrary, donor; Shades of Monterey Collection, No. 6462.)

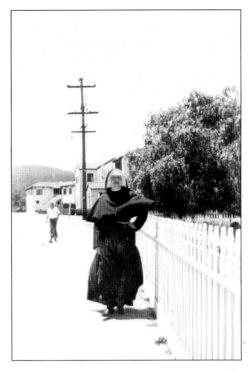

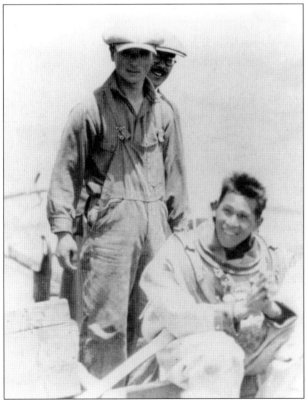

ABALONE DIVER AND CREW. Abalone and lobster divers Toichiro Takigawa, (front, right) and Tajuro Wantanabe (standing) are seen with crewmen on Monterey Bay in this 1923 photograph. The abalone diving industry thrived in Monterey largely due to innovations in the diving suit and helmet, introduced by Gennosuke Kodani. In the 1930s both Takigawa and Wantanabe owned their own diving vessels, the *Standard* and the *Empress*, respectively. (William Takigawa, donor; Shades of Monterey II Collection, No. 6325.)

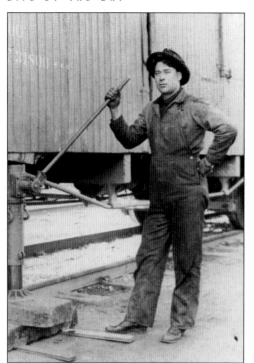

CHARLES MCFADDEN ON THE RAILROAD. Charles McFadden pauses for a moment while working for the Southern Pacific Railroad in 1913. Charles was one of seven children born to Thomas Abraham "Abe" and Annie Fadden. He and his brother Richard changed their name back to the original McFadden. Charles attended school at historic Colton Hall (the site of California's 1849 constitutional convention). His first job, in 1898, was caddying for a golf foursome comprised of department store magnate Marshall Field; Field's secretary Arthur Clayton; Robert Lincoln, son of Abraham Lincoln; and Miss Eleanor Sears of the Sears-Roebuck stores. During the afternoon Lincoln asked Charles if he ever went to church. Charles said, no, that he couldn't go to church wearing overalls. Before leaving town, Lincoln took Charles to the clothing and dry goods shop on Alvarado owned by Michael Harris and outfitted him head to toe. (Marge Turnbull, donor; Shades of Monterey Collection, No. 6657.)

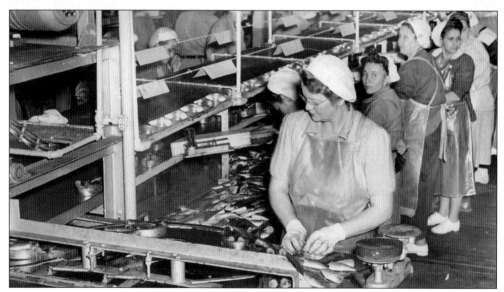

WOMEN CANNERY WORKERS. Women cannery workers pack sardines in one-pound oval cans along the line at Cal Pac on Cannery Row. The woman in the foreground is "repacking" sardines to refill spilled cans or to fill incomplete ones. When the whistles blew at the canneries, women would listen for the special whistle identifying their cannery. Washing, cooking, sewing, even child-care, ended as they rushed off to work. Women generally did the cutting and packing. At the height of the season, they would work 12 to 15 hours a day. One former cannery worker recalled how "people covered for you when you were tired. We looked out for each other." (George Robinson, photographer; Historic Photo No. 2970.)

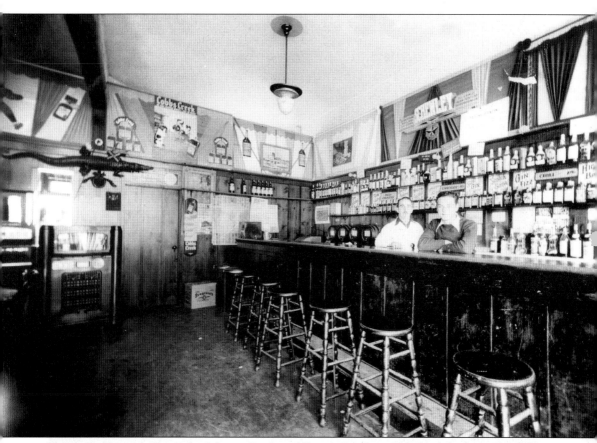

BRUCIA'S TAVERN. Bartender Johnny Garcia and Jimmy Brucia stand behind the bar at Brucia's Tavern on Alvarado Street. Jimmy's father, Antonio Brucia, established a small grocery store on Pacific Street in the late 1920s, then opened the doors to Brucia's Tavern at 242 Alvarado (where the Doubletree Hotel now stands). Antonio Brucia not only dispensed drinks to customers, he helped fellow Italians with their legal and immigration papers. In 1927, he organized the Sons of Italy in Monterey. After his death in 1937, son Jimmy took over the business. Antonio's daughter Toni Brucia recalls when John Steinbeck would stop by the bar in the old days. In 1962, Johnny Garcia was the bartender at The Keg, also on Alvarado, when Steinbeck returned to visit Monterey on his *Travels with Charley* cross-country tour. Steinbeck wrote: "I visited old places. There was a touching reunion in Johnny Garcia's bar in Monterey, with tears and embraces, speeches and endearments. . . . The years rolled away. We danced formally, hands locked behind us. And we sang . . . " (Toni Brucia, donor; Shades of Monterey Collection, No. 6339.)

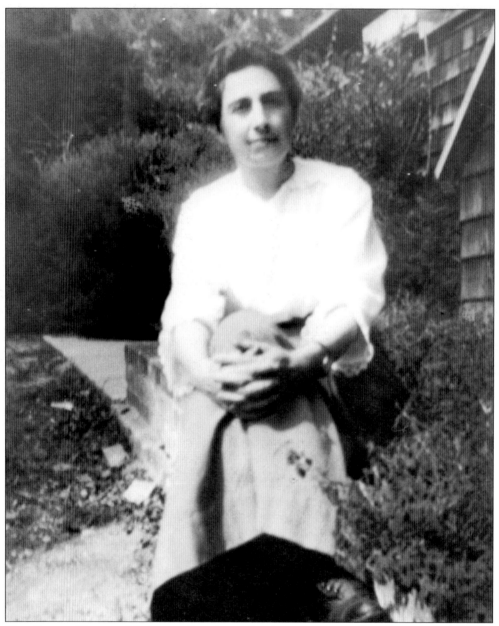

DR. SARAH HATTON McAULAY. Daughter of Irish immigrant William Hatton, who gained prominence for his extensive Carmel Valley dairy ranch and creamery holdings, Sarah was born at Los Laureles Ranch in 1880. In 1905, she married pioneer and mining adventurer Martin McAulay, a classmate at Hahnemann Medical College, which later became a department of the University of California, San Francisco, Medical School. When they moved to Monterey in 1908, they were among the first medical doctors in the region. In 1922 they established the El Adobe Hospital in the historic Pacheco Adobe at Abrego and Webster Streets. The couple had four children: William, Florence, Howard, and Elizabeth. Sarah was killed tragically at the age of 42 in an automobile accident on Carmel Hill Road. (Tamsin McAulay, donor; Shades of Monterey Collection, No. 7004.)

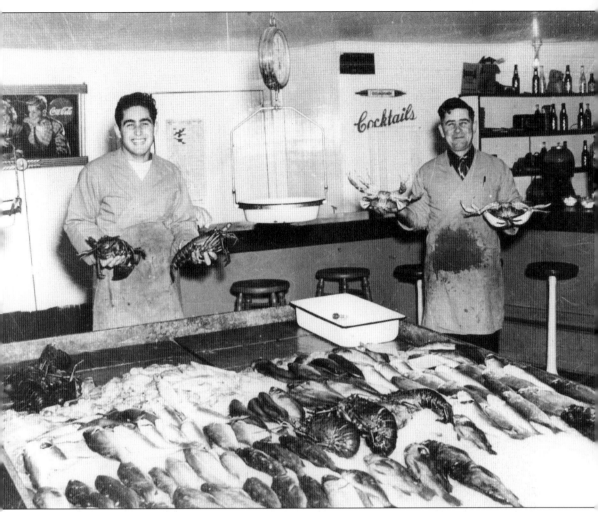

ANASTASIA'S FISH MARKET. Angelo Anastasia (left) and his father, Joseph, appear inside the family fish market located at 14 Municipal Wharf, about 1945. Joseph was a Sicilian immigrant who came to the United States, "the land of opportunity," in the 1920s. After working unhappily in the cotton mills of New Jersey, he came to Monterey. He and his wife, Jennie, lived on Jefferson Street, and later at 888 Pacific Street, where they raised four sons, Phillip, Joseph Jr., Angelo, and John, and one daughter, Rosalie. (Angela McCurry, donor; Shades of Monterey Collection, No. 6233.)

MARY MAROTTA DeMARIA CHAPPELL. Mary came to the United States from France in 1918, a widow with five children. In 1925 she married James Chappell and had two more children. Mary was a skilled tailor and made all her own clothes. With her stylish appearance and her reputation for having sold wine from the back of the family grocery store, it is no wonder that she was identified in this family photo as "Queen of the Bootleggers." (Laurie Hambaro, donor; Shades of Monterey Collection, No. 6056.)

C H A P T E R T W O

ALL DRESSED UP

PETERSEN BROTHERS AND MOM. From left to right, Leland, Bruce, and Darrell Petersen with their mother, Lucille, c. 1930. As young adults, the three boys joined the workforce as mechanics in the family business. The Monterey Garage was operated by three generations and was established in 1915 by Lucille's father, W.E. Spoon. The business was managed and later purchased by Lucille's husband, Edward. The Petersen family lived at 201 Watson Street in Monterey. (Leland Petersen, donor; Shades of Monterey, No. 6971.)

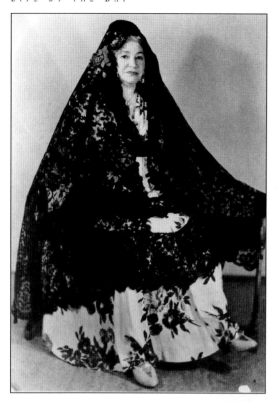

MARGARITA CASTRO. Margarita Castro displays one of her many Spanish dresses and a mantilla, which have been handed down in her family and which she has worn to many Meriendas and other Monterey celebrations. Margarita Artellan married rancher Antonio Maria Castro, a member of another old Monterey area family. After being introduced by her cousin Fred Boronda at a party in 1912, Tony gave Margarita a diamond ring. Five years later the Castros from Big Sur, the Artellans, and other family members arrived for Tony and Margarita's wedding at the old San Carlos Church in Monterey. (Historic Photo No. 1089.)

JOHN HELLAM. In this 1960 photograph, John Hellam poses behind the counter of his tobacco shop at 413 Alvarado Street, where he also sold trick party gadgets. Brothers John and Lee Hellam operated the tobacco shop, originally named the Climax Cigar Store, which their father Frank Hellam opened shortly after he came to Monterey from Michigan in 1887. (George Smith, photographer; Harbick Collection.)

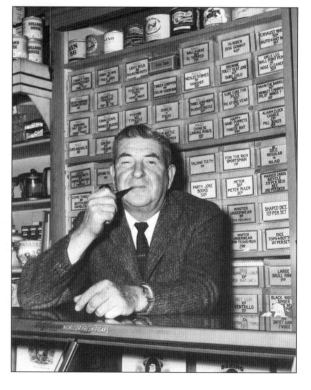

ROSE VALDIVISTO AND ELIZABETH CASTRO.
Rose Valdivisto and her friend Elizabeth Castro
show off their fancy dresses in this *c.* 1937
photograph taken in Rose's yard at 704 Foam
Street. Rose's husband, Leo, was a cannery
worker. Elizabeth (née Shiffer), who was also a
cannery worker, was married to Luis Agudo at
a young age. Luis was the founder of the
Filipino Independent News and a labor organizer
for Filipino agricultural and cannery workers.
After they divorced, Elizabeth married Frank
Castro and together they raised both the Agudo
and Castro children as one family. (Jean
Cordero, donor; Shades of Monterey
Collection, No. 6211.)

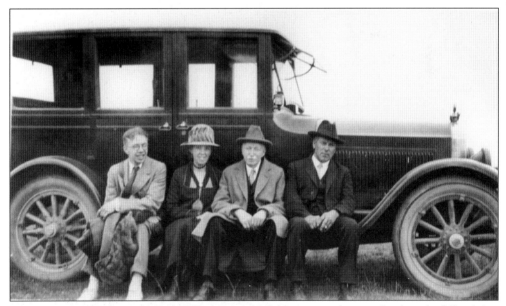

ALFRED JONES AND VISITORS. Alfred Jones (right) poses on the running board while giving
a tour of the Monterey Peninsula to visitors about 1920. The Jones family originated in
England, migrated to Montana, and came to the Monterey area in 1921. (Ruth Jones, donor;
Shades of Monterey, No. 6230.)

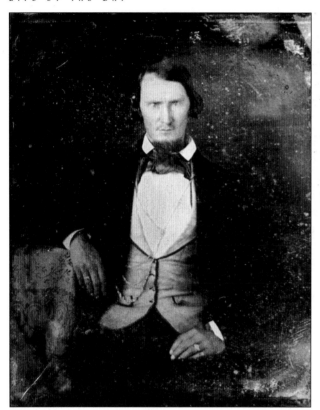

GENTLEMAN GAMBLER.
William B. Pyburn appears in this tintype photograph, taken about 1856. Pyburn, born in Louisiana, arrived in Monterey by 1850 during the California Gold Rush. He quickly established himself by setting up "gaming tables" for returning miners and others to play their hand at "monte" in establishments like the Bola de Oro (Ball of Gold), a combination barber shop and saloon on Alvarado Street. Pyburn also bought a Mexican rancho, the Coral de Padillo, for orchards and a horse ranch. He married Hannah Brown, an emigrant from Australia, who later ran the Central Hotel. (Muriel Gould Pyburn, donor; Historic Photo No. 4628.)

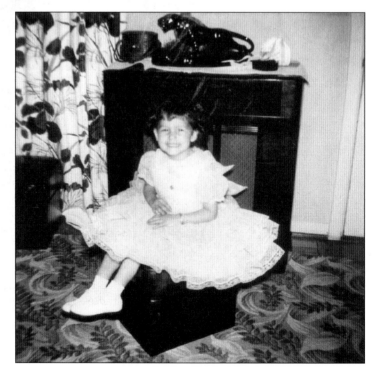

ANGELA ANASTASIA.
Angela Anastasia models her new Easter dress in her parents' home on Newton Street in 1956. Angela is the daughter of Angelo and Ruth Anastasia, and sister to Millie, Angelo Jr., and Joseph. (Angela McCurry, donor; Shades of Monterey, No. 6248.)

DOROTHY KIRBY AND FRIEND. Dorothy (née Emigh) Kirby and friend wear stylish hats in this *c.* 1940 photograph. Dorothy's family was of English and German descent, and she worked as a sardine packer. She was married to Joseph Kirby, with whom she owned the Silver Dollar Bar and Grill and had four sons. (Robert Kirby, donor; Shades of Monterey Collection, No. 6616.)

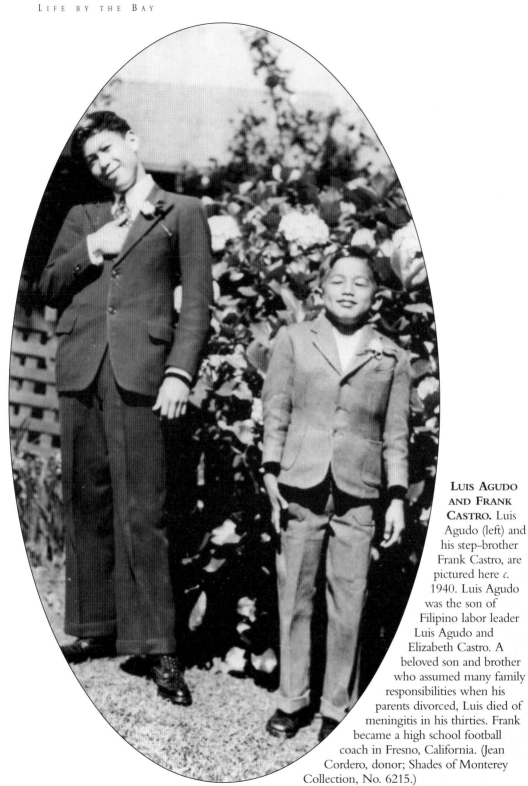

LUIS AGUDO AND FRANK CASTRO. Luis Agudo (left) and his step-brother Frank Castro, are pictured here *c.* 1940. Luis Agudo was the son of Filipino labor leader Luis Agudo and Elizabeth Castro. A beloved son and brother who assumed many family responsibilities when his parents divorced, Luis died of meningitis in his thirties. Frank became a high school football coach in Fresno, California. (Jean Cordero, donor; Shades of Monterey Collection, No. 6215.)

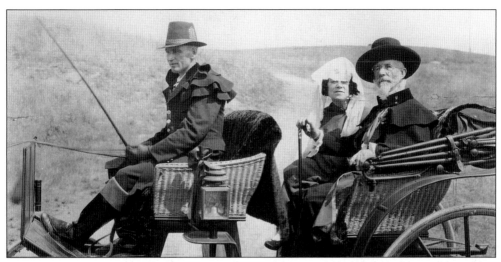

HARRY ASHLAND GREENE AND VIRGINIA NORRIS. Harry Ashland Greene and Virginia Norris are pictured en route to one of Monterey's gala fiestas, *c.* 1930. Known for his civic energy and enthusiasm, Harry Greene, nicknamed the "father of Monterey," was credited with advancing more community improvement projects than any one person. These included the harbor breakwater and railroad projects, bringing electricity to the Monterey Peninsula, organizing the Bank of Monterey, and the building of the first modern hotel in Monterey, the Monterey Hotel. He died in 1933. Seated with Greene is Virginia Norris who operated an antique shop in New Monterey and later in the Casa Gutierrez Adobe on Calle Principal. (Historic Photo No. 3471.)

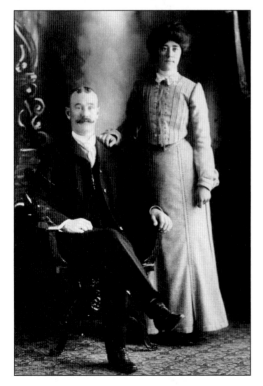

GERTRUDE FADDEN AND JOE BROWN. Gertrude Fadden, about 16 years old, was unhappily wed to forty-something Joe Brown, in a marriage arranged by her mother, Annie Fadden. Gertrude died tragically within a year of her marriage. This photograph dates to *c.* 1900. (Marge Turnbull, donor; Shades of Monterey Collection, No. 6652.)

33

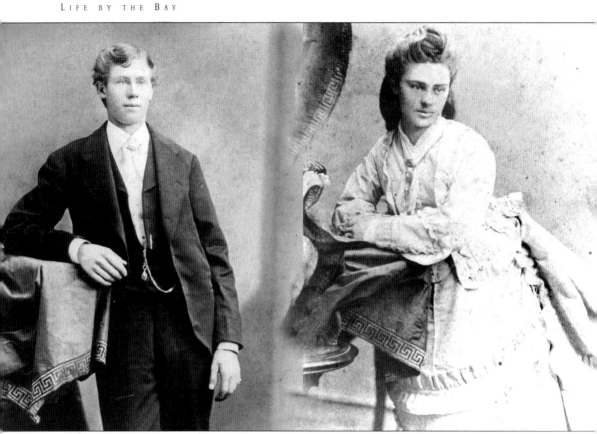

WILLIAM HENRY PYBURN AND JULIA ESCOLLE'S WEDDING, 1874. Henry began work in Honore Escolle's general store in the Cooper-Molera building and soon married Escolle's daughter Julia. Pyburn later operated a grocery store and a saloon, but opted to enter civic life during which he held several county offices. Away on business in 1886, Henry wrote to Julia the following words:

> Your very much unexpected letter came safely to hand. . . . Our lives have been joined together for 12 long years. My mind is always fixed on you and the love I bear for you grows stronger every day. Fifteen years ago I first loved you and since that time my love has ever day increased and will continue to do so. You may think these idle words but mistake them not, for they are the sentiments of my heart.
> (Muriel Gould Pyburn, donor; Historic Photo No. 2246-47.)

HELEN AND ALICE PIAZZONI. Sisters Helen (left) and Alice Piazzoni, pictured *c.* 1920, are the daughters of Luigi Piazzoni and Tomasa Fiesta Manjares. Luigi's family came to the United States from Intragna, Switzerland, and in 1884 purchased a large tract of ranch land in Carmel Valley. Tomasa is of Esselen Indian ancestry. Helen and Alice were both accomplished cowgirls who could rope and ride bulls, and they regularly participated in rodeo events. Alice was one of the first Salinas Rodeo Queens. Helen married William "Wild Bill" Cordero, who was a card dealer and later worked in security at Fort Ord. Alice married Charles Varien and moved to Pacific Grove. (Jean Cordero, donor; Shades of Monterey Collection, No. 6208.)

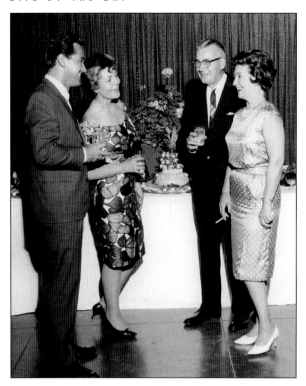

RUDY RICHTER AND FRIENDS. In this 1965 photograph, Rudy Richter, manager of the Casa Munras Hotel, and Mrs. Jack Dougherty chat with Mr. and Mrs. Jack McCubbin, the new co-owners of the hotel. Jack Dougherty's father, Paul, a former mayor of Monterey and postmaster, bought the fine old Munras adobe and converted it into a hotel. (MacDougall King, photographer; Harbick Collection.)

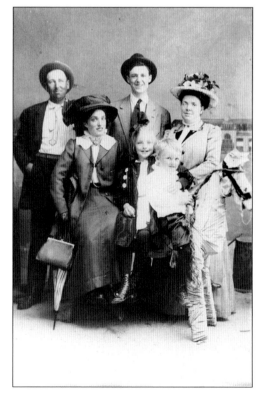

THE ANTHONY FAMILY. On the left is J.C. Anthony, a well-known local builder who pioneered the use of chalk rock, sometimes called "Carmel stone," for building. J.C. came to California from Iowa in 1884, at the age of 11. Fourth from the left is J.C.'s wife, Edna (née Wright) of Volona in Contra Costa County, whom he married in 1900. The Anthony children—Joy and J.C. Jr.—are pictured c. 1907. (Jan McLean Jones, donor; Shades of Monterey II Collection No. 6123.)

ISABEL MEADOWS. Isabel Meadows was born in Carmel Valley on July 7, 1846, the day the American flag was raised over Monterey's Custom House. The daughter of former whaler and pioneer James Meadows and Loretta Onesimo Meadows, a member of a local Indian family, Isabel was a speaker of the Rumsien Ohlone language, the native language spoken in the Monterey coastal region. She lived in Monterey at 614 Belden Street until the early 1920s. At age 87, she went to the Smithsonian Institution in Washington, D.C., to record the Rumsien language and assist Professor John Peabody Harrington with his research into the life and culture of the Rumsien people. She died there at age 93. (Historic Photo File, No. 295.)

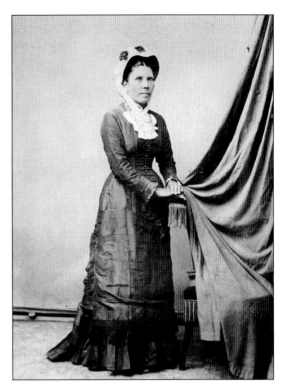

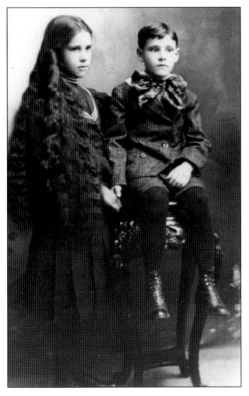

RUTH ELLEN AND RICHARD JOSEPH FADDEN. Siblings Ruth Ellen and Richard Joseph Fadden pose in this 1910 photograph. Richard, who later changed his name to McFadden, co-owned a large piece of Carmel Valley property past Garza's Creek with his brother Charles. He eventually became a plumber and lived at 227 Clay Street. Ruth Ellen married James Lockhead, a bookkeeper at the Bayside Cannery. (Marge Turnbull, donor; Shades of Monterey, No. 6664.)

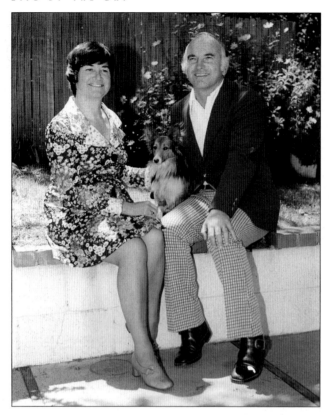

JOANNE VOUT ALBERT AND DAN ALBERT, 1974. Joanne and Dan have been sweethearts since their junior high school days at Walter Colton School. Dan Albert was varsity baseball and football coach at Monterey High School, where he was also a member of the 1948–1949 championship team. After 37 years teaching and coaching, Albert was elected to the city council, then mayor of Monterey in 1986. (Harbick Collection.)

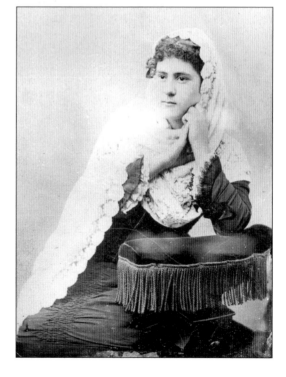

ANNIE FADDEN. This photograph of Annie Brown was taken from a tintype made prior to her wedding in 1882 to Thomas Abraham "Abe" Fadden. Annie, the daughter of Maurica Duarte, was born near the banks of Espinosa Lake in Castroville. The Duarte family, of Spanish and French ancestry, migrated to California from Spain via Mexico in the early 1800s. (Marge Turnbull, donor; Shades of Monterey, No. 6647.)

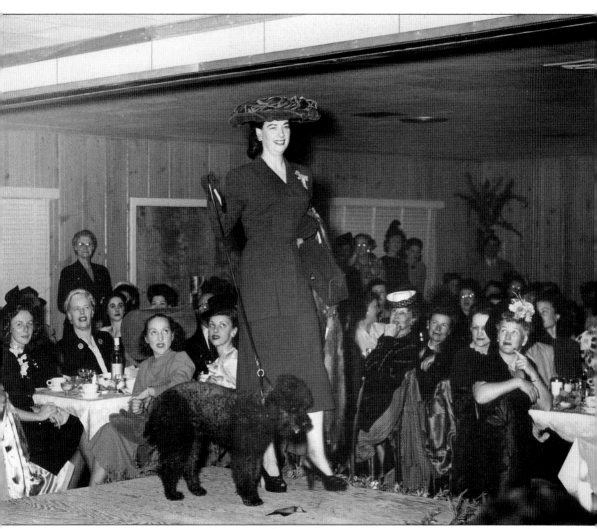

IN FASHION. The Business and Professional Women of Monterey sponsored Wilma Campbell's style show at the Barbecue Inn in 1947. Mrs. Ellis Bovik of Monterey wore a sheer wool Herbert Sondheim suit and an original Wilma Campbell hat. (Fred Harbick, photographer; Harbick Collection.)

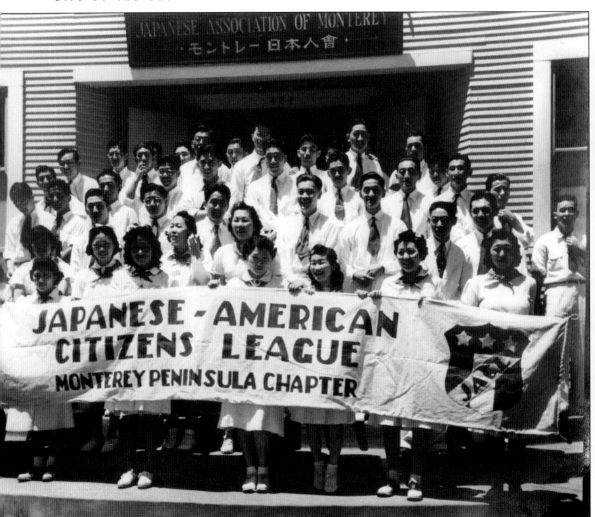

JAPANESE-AMERICAN CITIZENS LEAGUE. Members of the JACL line the steps of the Japanese-American Citizens League Hall at 424 Adams Street in 1940. The hall was built in 1926 by the Japanese Association (Nihonjinkai) as a place where the Japanese community could gather, share cultural interests, and hold special events. When World War II broke out, the property title transferred to the Japanese American Citizens League in an effort to protect the property from confiscation. During the war years, the hall was used as a National Guard armory. Immediately after the war, the hall served as a hostel for Japanese Americans returning from internment camps, and the JACL assisted the returning families with compensation claims. The JACL continues to serve the political, social, and cultural interests of the Japanese-American community. (George T. Esaki, photographer; Jean Esaki, donor. Shades of Monterey II, No. 7138.)

COMMUNITY SPIRIT

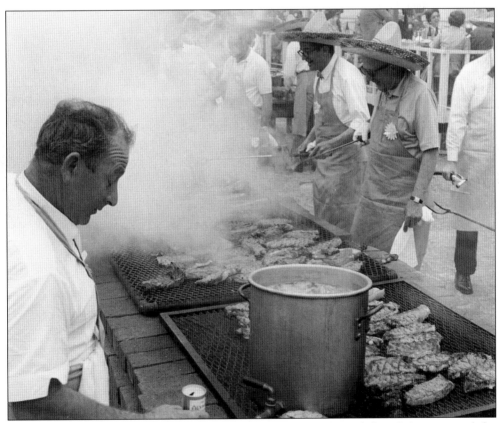

BARBECUE AT THE 199TH ANNUAL MERIENDA. The traditional feast being prepared for Monterey's birthday party in 1969 was held in Memory Garden, behind the Pacific House. The fellows with the long-handled forks turned the steaks over wood fires. In the foreground, a huge pot of frijoles simmers. (MacDougal King, photographer; Harbick Collection.)

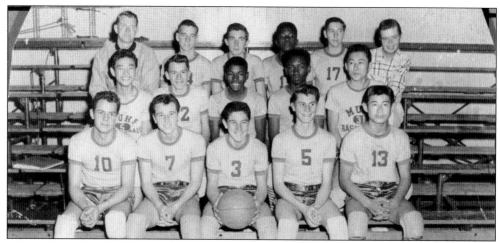

MONTEREY HIGH SCHOOL BASKETBALL TEAM. Members of Monterey High School's 1954 "Toreababes" lightweight basketball team include the following, from left to right: (front row) Ken Yeager, Mannie Lucido, Andy Gonzales, Gene Moscuzza, and Tosh Okumura; (middle row) Dick Bobayashi, Mike Prieto, Richard Woods, Alvin Green, and Louis Yamanishi; (back row) Coach Clark, Tod Sperling, George Collins, Ronnie Palmer, Vince Torrente, and Karl Ohrt. Senior Andy Gonzales (in jersey Number 3) made the All-Central California Athletic League (CCAL) team. Andy married his high school sweetheart, Ann Prego (class of 1959), and became a teacher at Monterey's Walter Colton Middle School. (Ann Prego, donor; Shades of Monterey Collection, No. 6416.)

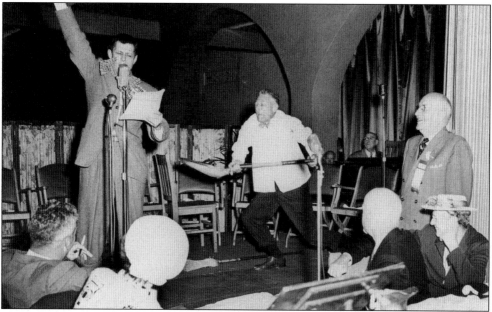

MONTEREY ROTARY CLUB. Rotarians perform a skit, *c.* 1950. On stage are City Librarian Delbert "Jeff" Jeffers (at the microphone) and Douglas Bradburn. Seated, from left to right, are Paul Zaches, Mrs. Hugh Dormody, Carmel Martin Sr., and an unidentified woman. Rotary International is a service club with chapters worldwide. (Joan Jeffers McCleary, donor; Shades of Monterey II Collection, No. 7213.)

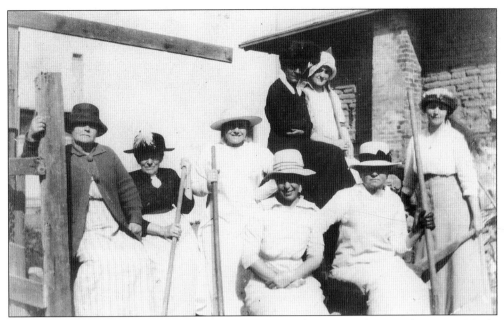

THE MONTEREY CIVIC CLUB CLEANS UP. Pictured in this *c.* 1909 photograph are Mrs. Hattie Gragg, Mrs. Frank Zimmerman, Mrs. Louis Goldstone, Mrs. Colioell, and Mrs. Hilby. In the rear are Mrs. Dick Sargent and Mrs. Bergschicker. The Monterey Civic Club was founded on March 15, 1906, by a group of 34 women for the purpose of preserving and contributing to the welfare of Monterey. Among early club projects were cleaning, planting, and decorating gardens and lots, promoting "footpaths and bridges" across gullies, and "closing saloons from 11 PM to 5 AM." In 1914 they saved and purchased as their clubhouse the House of Four Winds adobe. (Historic Photo No. 218.)

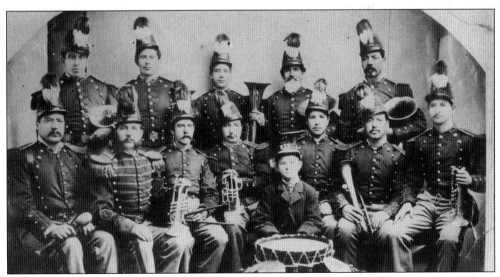

THE MONTEREY BAND OF THE 1880s. Pictured, from left to right, are the following: (front row) Andy Sanchez, Jabin Harris, Ed Allen, Charlie Rodriguez, Adolf Sanchez, unidentified drummer boy, unidentified, and Nelson Little; (back row) Bob Duckworth, Santa Maria Duarte, (?) Gomez, Felipe Gomez, and unidentified. (Historic Photo No. 44.)

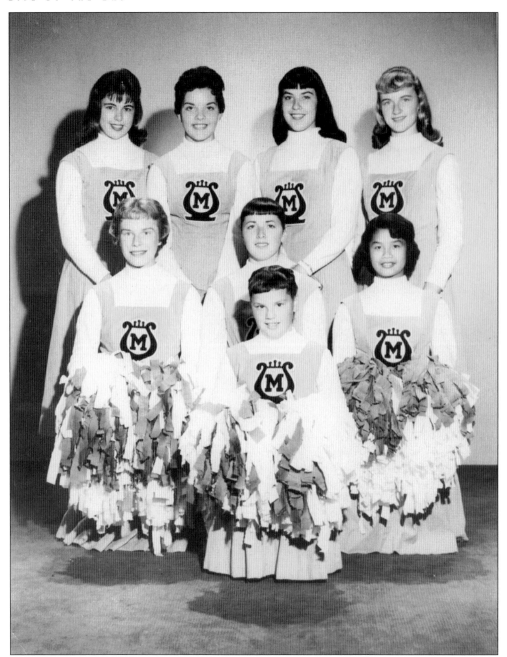

MONTEREY HIGH SCHOOL SONG GIRLS. Monterey Union High School's 1957 "Pom Pom Squad" boosted support for sports teams and worked hard to promote school spirit. From left to right are (front row) Betty Milazzo; (middle row) Charlene Hilton, Pilar Milazzo (head song leader), and Melanie Monar; (back row) Bobbi Ventimigila, Virginia Vierra, Joyce Bushnell, and Ann Prego. (Ann Prego, donor; Shades of Monterey Collection, No. 6428.)

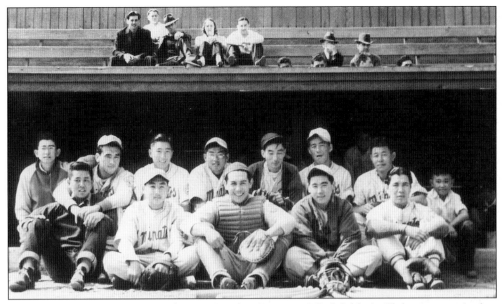

MINATO ATHLETIC CLUB. In about 1930, the Monterey Nisei Athletic Club was organized as a way for Japanese children to enjoy sports and form friendships. The name of the club evolved into "minato," meaning harbor or bay. Because of its popularity, baseball was the first sport organized by the Minato Club. This is a Minato baseball team from the mid-1930s. Later, Minato basketball and track teams were formed. The Minato teams were renowned for their good sportsmanship and excellent athletic ability. They won many championships in the Central Coast during the 1930s and 1940s. The club passed into history in the 1950s. (George T. Esaki Photographer; Jean Esaki, donor. Shades of Monterey II Collection, No. 7137.)

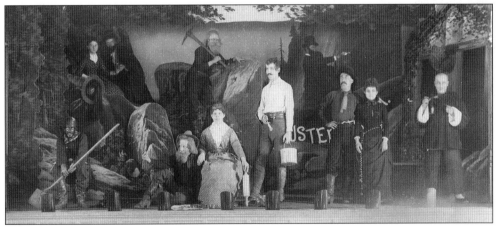

THE MONTEREY DRAMATIC COMPANY. This March 4, 1889, photograph shows the drama troupe in a stirring performance of *Nevada or the Lost Mine*. Local residents who performed included merchant Henry Friedmen as Jerden, the detective; W.R. Thomsen; Jennie Cohn as Agnes; and Adolf Guzendorfer, proprietor of the popular White House store, as Win-Kye. The miner in the background may be a well-known local character in his own right, Charles W.J. Johnson, staff photographer at the Hotel del Monte. Johnson arrived in California during the Gold Rush and worked as a miner, carpenter, and musician, playing a unique combination of guitar and tuba. (C.W.J. Johnson, photographer; Historic Photo No. 3507.)

45

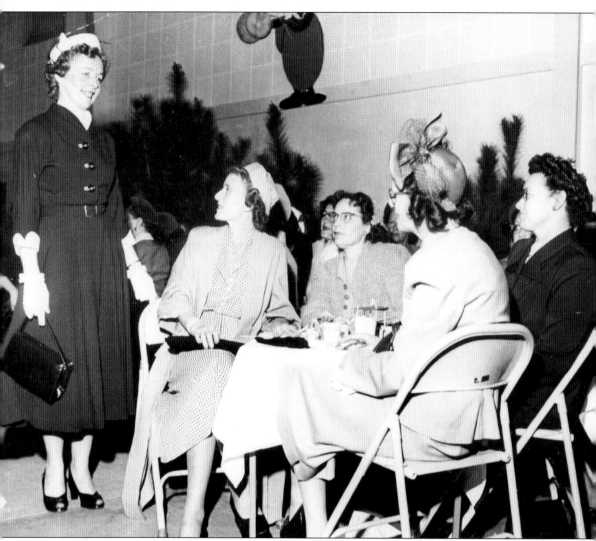

TAU MU ANNUAL FASHION SHOW. Mrs. C. Pierce Parsons models fashions from Holman's Department Store at the Tau Mu sorority's annual spring Fashion Show in March 1952. The fundraising event was held in Exposition Hall at the Monterey Fairgrounds and welcomed over 500 guests. Seated, from left to right, are Virginia Schetter, Wilma McKay, Gladys McKay, and Helen Abinante. (Natalie Whitney, donor; Shades of Monterey Collection, No. 6049.)

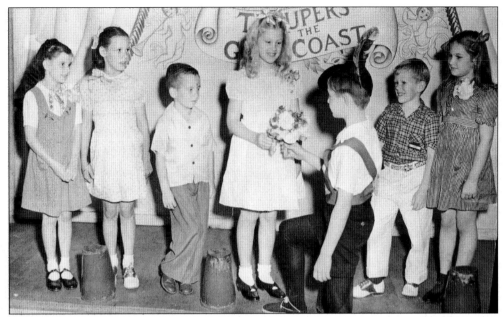

AT CALIFORNIA'S FIRST THEATER. Children join in a birthday celebration for 9-year-old Elizabeth Beal at the First Theater, about 1946. From left to right are Helen Jacques, Ruth Reed, Don Jacques, Elizabeth Beal, unidentified, David Beal, and Ann Graham. The First Theater, located at Scott and Pacific Streets, was built by Jack Swan, an English sailor who settled in Monterey in 1843. The building was originally used as a tavern and lodging for seamen. In the 1920s it was a tearoom. In 1937, the Troupers of the Gold Coast began performing authentic melodramas in the First Theater and continued to do so until the theater closed temporarily for renovations in 2001. The Troupers continue to perform in other venues and are believed to be the oldest continually operating theater company in the United States. (Ann Quattlebaum, donor; Shades of Monterey Collection, No. 6820.)

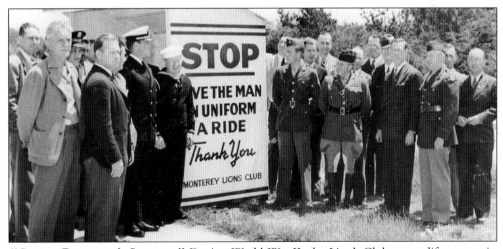

"GIVE A RIDE TO A SOLDIER." During World War II, the Lion's Club gave a lift to men in uniform by providing shelters where servicemen could wait for rides. Signs on the shelters encouraged drivers to do their part for the armed forces. This photograph is dated 1942. (Natalie Whitney, donor; Shades of Monterey Collection, No. 6048.)

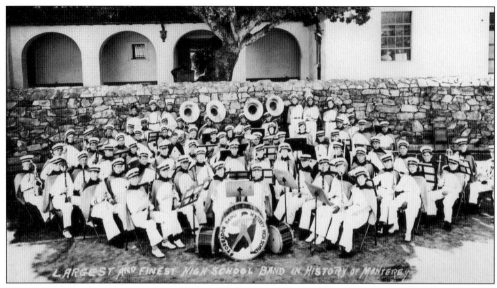

HIGH SCHOOL BAND. Monterey Union High School Band from the 1936–1937 school year in their long-awaited new uniforms. Sydney Manning, the son of Doris and Louis Manning, is in the front row, the fourth clarinet from the left. Syd served in the U.S. Air Force during the Second World War. (Evelyn Crumpley, donor; Shades of Monterey Collection II, No. 6543.)

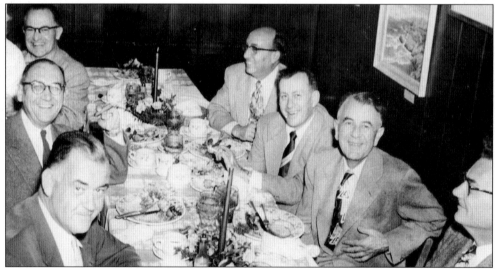

MONTEREY PENINSULA ASSOCIATES. Present at this November 13, 1953, gathering are (left side of table, front to back) Les Dewer, Roudi Partridge, Fred X. Fry, and (right side of table, front to back) Wright Fisher, unidentified, Jack Tostevin, and Leonard Abinante. The Monterey Peninsula Associates was founded in 1945 by a group of business and professional men "to investigate and back worthwhile civic, cultural, and recreational projects." The members gathered at a monthly dinner for fellowship, to exchange ideas, and discuss current topics. The group functioned as a service club working for community improvement. They were also the investors who developed the Monte Vista Park subdivision. Their roster of several dozen members was a "Who's Who" of local business and civic leaders from the 1940s, 1950s, and 1960s. (Natalie Whitney, donor; Shades of Monterey Collection, No. 6052.)

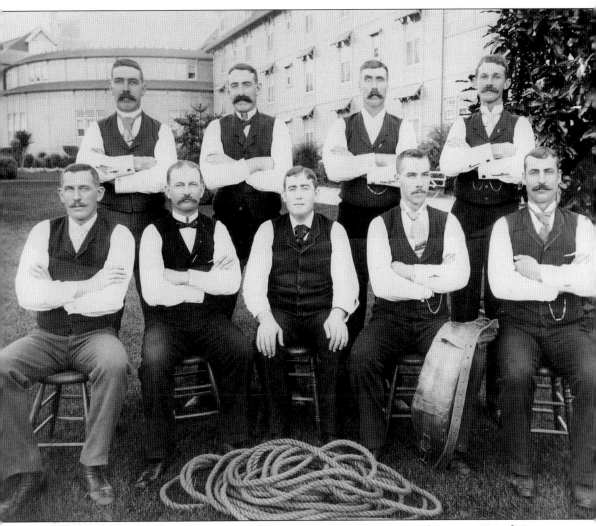

THE DEL MONTE CHAMPIONS TUG OF WAR TEAM. The Del Monte Champions Tug of War Team of October 14, 1894, stands proudly before the old Del Monte hotel. The champions competed against two other teams—the Wharf Rats and San Carlos—during a four-day Fair of Nations held to benefit San Carlos Church. The Wharf Rats, who had practiced nightly on the wharf, won the first tug after 30 minutes. The next day, the Del Montes pulled their opponents, the San Carlos, off their feet in just three and a half minutes. Finally, on October 12, the mighty Del Montes overcame the Wharf Rats in 27 minutes and took the purse of $40! The team noted that their object was the glory, not the monetary prize. On the upper right among the stalwart fellows clad in white shirts, celluloid collars, and vests is William Gould, later mayor of neighboring Pacific Grove. (Muriel Gould Pyburn, donor; C.W.J. Johnson, photographer; Historic Photo No. 3508.)

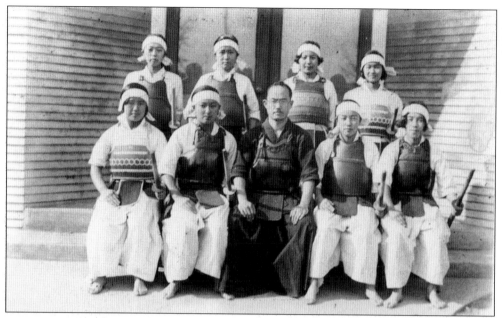

KENDO TEAM. Members of a Kendo team, a Japanese form of fencing, are pictured here in the 1930s. In the back row, third from left is Sachi Higuchi–Oka and to his right, Nobkuo Higashi Takigawa. (George Kodama, donor; Shades of Monterey Collection, No. 7025.)

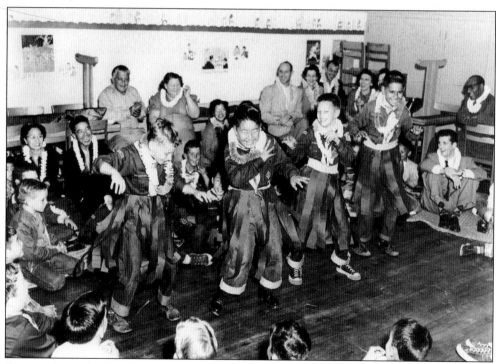

PTA EVENT. The members of the Parent–Teacher Association of Bayview Elementary School are entertained by hula dancing Cub Scouts, *c.* 1951. (Pam Chrislock, donor; Shades of Monterey II Collection, No. 7101.)

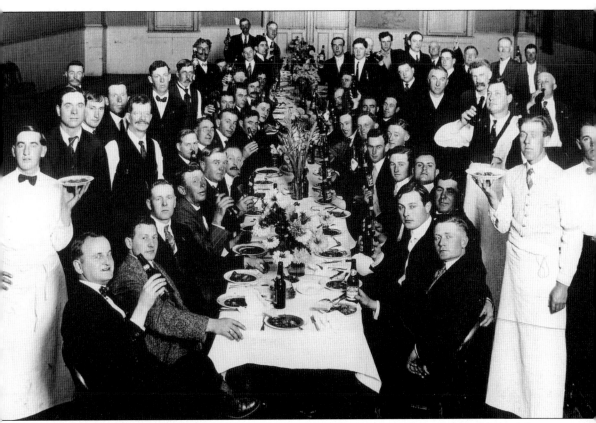

THE STICKERS' CLUB. This banquet held by the Monterey Stickers' Club, a men's athletic club, occurred in the early 1920s. John Gartshore, father of local journalist Bonnie Gartshore, stands second from left. Little is now known about this organization except that it had a ball team and sponsored several vaudeville shows. In 1930 they held their meetings at 303 Alvarado Street. (Bonnie Gartshore, donor; Shades of Monterey Collection II, No. 6151.)

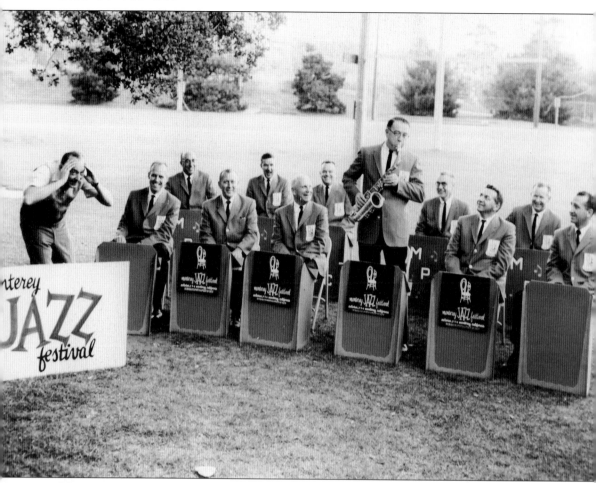

MONTEREY JAZZ FESTIVAL DIRECTORS. Bandleader Woody Herman stands with directors of the Monterey Jazz Festival in 1958. From left to right are (front row) Mel Isenberg, Jack Tostevin, Frank Wilkinson, John Coyle, Sam Karas, and Ed Larsh; (back row) Leonard Abinante, Hal Hallett, unidentified, Jack Kraft, and George Wise. (Natalie Whitney, donor; Shades of Monterey Collection, No. 6050.)

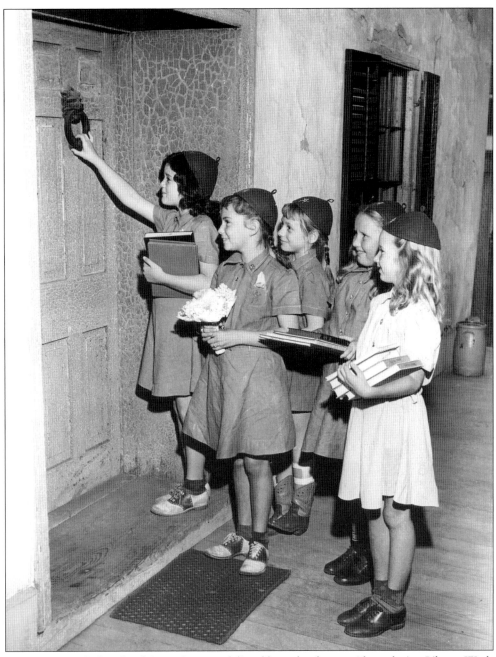

BROWNIES. Girls from local Brownie troop deliver library books to residents during Library Week in this November 17, 1947, photograph. (Peter Breinig, photographer; Historic Photo No. 8027.)

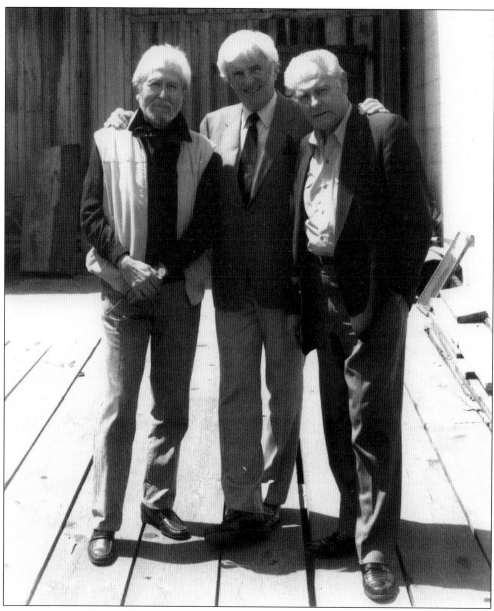

GUS ARRIOLA, HANK KETCHUM, AND ELDON DEDINI. The three famous cartoonists stand in back of Ed Rickett's laboratory and biological supply house, Pacific Biological Laboratory on Cannery Row, 1984. The building was the original model for the Western Biological building in Steinbeck's *Cannery Row* and *Sweet Thursday*. The three friends were members of the Lab group. After Rickett's death in 1948 a small group of artists, physicians, attorneys, and businessmen began meeting at the Lab, owned by Harlan Watkins, a high school literature teacher. The Lab group met for dinner, camaraderie, and to discuss literature, music (especially jazz), and daily events. Several members were well-known artists, including Eldon Dedini, featured cartoonist in the *New Yorker* and *Playboy*. Gus Arriola created the popular *Gordo* cartoon, and Hank Ketchum created *Dennis the Menace* cartoons and books. (Jerry Takigawa, photographer; Ilene Tuttle, donor. Historic Photo No. 5032.)

C H A P T E R F O U R

JUST FRIENDS

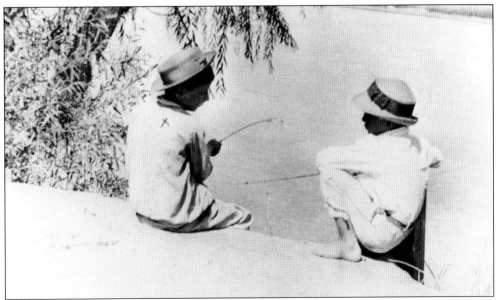

E.E. JAMES AND FRIEND. Edgar E. James and friend are seen fishing at James Camp (now called Pico Blanco) in 1898. The friends camped, fished, and hunted for two weeks. James was the youngest son of W.W. James, who came to Monterey from Missouri in 1874 and became a prominent businessman, civic leader, and postmaster under three presidents. Edgar grew up to distinguish himself as one of the founders of the Monterey Bank, which he managed from 1928 until its consolidation with the First National Bank in 1942. (Edith James Karas, donor; Shades of Monterey Collection, No. 6004.)

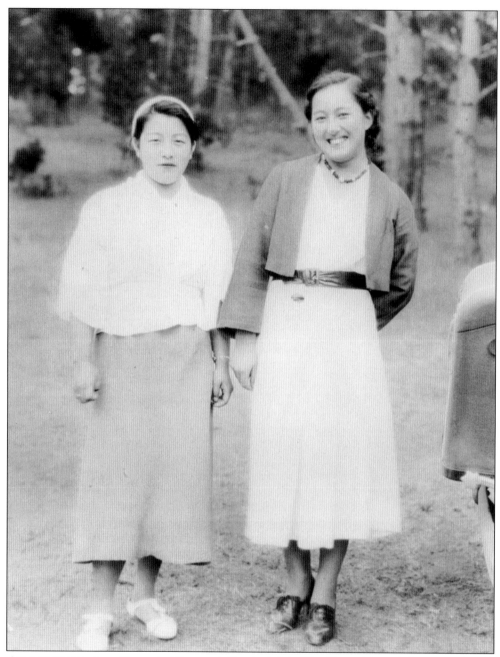

AIKO HATTORI AND YOSHIKO HIGUCHI. On the left is Aiko Hattori (married name Ito) with Yoshiko Higuchi (married name Beppu), Monterey Union High School coeds, *c.* 1930. Aiko's grandparents Sekisaburo and Tama Hattori came to the United States from Japan and settled in Monterey in 1921. Aiko was an excellent student and earned a scholarship to Stanford, but had to turn it down in order to help the family pull together resources to educate her younger brother. Yoshiko Higuchi distinguished herself at Monterey High in the areas of athletics, scholarship, and leadership, and was valedictorian for the graduating class of 1932. (George T. Esaki, photographer; Jean Esaki, donor. Shades of Monterey II Collection, No. 7127.)

TWO FRENCH IMMIGRANTS. Jules Simoneau and artist Jules Tavernier talk in front of Monterey's adobe jail. Tavernier arrived in Monterey in 1875. Among his new friends, who gathered in his studio on Alvarado Street, were poet Charles Warren Stoddard, painter Joe Strong, and his Joe's sister Elizabeth. Here the new bohemians sat among the paintings on wolf skins and Oriental rugs, smoking, drinking, and discussing art. When not in his studio, Tavernier led the group down to Jules Simoneau's restaurant, then located next to the old jail. The adobe jail had served Monterey from 1835 to 1849, and it stood in the triangle formed by Munras, Tyler, and Pearl Streets. There, Simoneau served *olla podrida*, a Mexican stew, and drinks. In 1879 he befriended another artist, a little-known writer named Robert Louis Stevenson. (Historic Photo No. 6.)

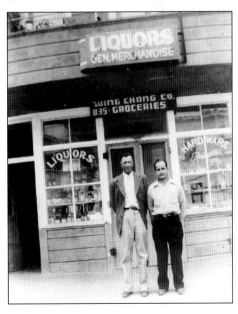

ORVILLE HOWARD AND GEORGE VERMILYER SR. Orville Howard (left) and George Vermilyer Sr. are seen here in front of Wing Chong's on Cannery Row, *c.* 1949. George Vermilyer and his wife, Lily, raised two sons (George Jr. and James) in the family home on Casanova Street. The Wing Chong market was immortalized in John Steinbeck's novel *Cannery Row* as Lee Chong's grocery, which "while not a model of neatness, was a miracle of supply." Wing Chong, which means "glorious, prosperous," was opened in 1918 by Won Yee and C.L. Sam. (James and George Vermilyer Jr., donors; Shades of Monterey II Collection, No. 6919.)

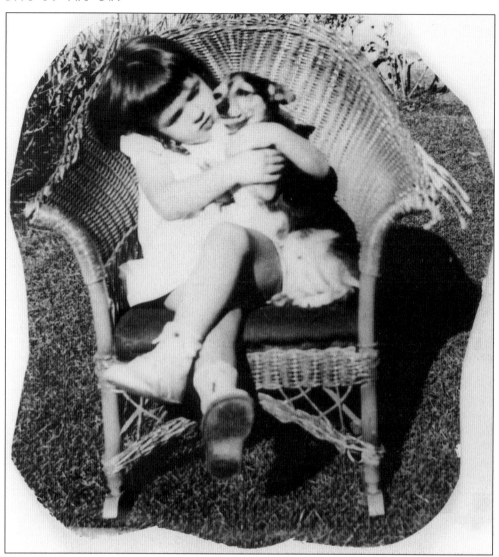

LINDA PREGO WITH MINNIE. Linda Prego is pictured here with the omnivorous family pet, Minnie, also known as "the vacuum cleaner dog." Linda's father, Andy, was of Spanish descent, and came to Monterey from Jackson, California in 1918. Her mother came to Monterey from Missouri in 1925. The family lived at 21 Via Paraiso. (Linda Thorpe, donor; Shades of Monterey II, No. 6512.)

DOROTHY KIRBY AND FRIEND. Dorothy Kirby (left), with her four sons—Robert, Alan, Richard, and James—and a friend, stand in front of the harbor at the annual Santa Rosalia Festival, *c.* 1945. Dorothy worked as a sardine packer and her husband, Joseph, owned the bar inside the Miramar Hotel on Pacific Street, near the entrance of the Presidio. (Robert Kirby, donor; Shades of Monterey Collection, No. 6619.)

JOHN SPENCER. "I surely feel like Rip Van Winkle," said John Spencer (left) upon returning to Monterey after 65 years. In 1910, Spencer returned to the place where in 1846 he had witnessed the American taking of the capital, Monterey, from the Mexican government. Arriving on the U.S. frigate *Savannah* under Commodore Sloat, he was a member of the landing party that raised the American flag over the Custom House on July 7, 1846. Rafael Castro, a member of a prominent Californio family of Monterey, was 11 years old at the time. Both Spencer and Castro had seen the raising of the flag and the Americans' march through the town. Within a few minutes of their meeting they became friends, sharing their reminiscences of old Monterey. (Historic Photo No. 3535.)

SILVIO INDORADO AND JOHN CINCOTTA. Silvio Indorado chats with John Cincotta, ship chandler and manager of the Cincotta Brothers supply store in this 1960 photograph. Silvio owned his own fishing boat and had fished Monterey Bay for over 40 years. John Cincotta's father, Anthony, and his brothers opened the marine supply store near the wharf in 1937. The Cincottas supplied the Sicilian and Portuguese fishermen with equipment and provisions for their boats; in the 1940s this number had grown to 72 boats sailing in and out of Monterey to catch sardines and deposit their catches at the canneries. After a day's fishing, the fishermen would gather at Cincotta's to swap yarns. (Harbick Collection.)

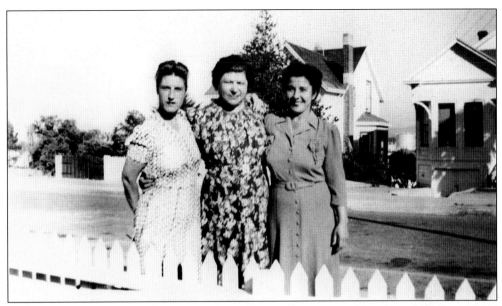

OCTAVIA ORTINS, GRACE BERVOSSI, AND LENA BALESTERI. The three friends meet on Larkin Street, near the Ortins family home at 478 Larkin Street, *c.* 1941. Octavia (left) is the granddaughter of Manual Ortins, a whaler who came to Monterey from Portugal in the late 19th century. Lena (right) is the wife of Sam Balesteri, waterfront leader and owner of Sam's Fishing Fleet. (Anthony Moltini, donor; Shades of Monterey Collection, No. 7006.)

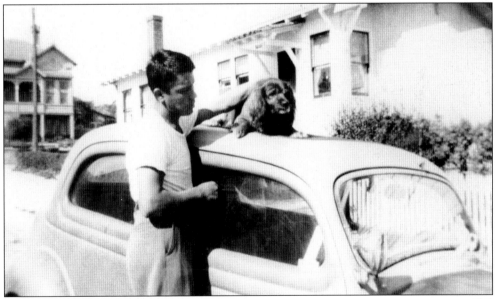

PHIL ALVARADO AND BUCKY. In this 1942 photograph taken at 360 Prescott Street, Phil Alvarado is seen with his cocker spaniel Bucky perched on the top of a 1936 Ford. Phil was well known locally as a welterweight boxer, and he later became a landscape gardener. His family came to Monterey in 1930 and worked in the canneries. Phil married Maryon Duran, a descendent of Governor Juan Bautista Alvarado. (Maryon Alvarado, donor; Shades of Monterey Collection, No. 6039.)

LILY VERMILYER AND FRIEND. Lily Vermilyer (left) "stops" to pose with a friend at the corner of Seventh and Ocean in the Oak Grove neighborhood, *c.* 1953. Lily and her husband, George, came to Monterey following World War II seeking work and good weather. (James and George Vermilyer Jr., donors; Shades of Monterey II Collection, No. 6912.)

EVELYN LEONARD AND MILLIE ANASTASIA.
Schoolgirls Evelyn Leonard and Millie Anastasia lounge on the field of the San Carlos School, *c.* 1958, with the historic San Carlos Church in the background. Millie is the daughter of Angelo and Ruth Anastasia. (Angela McCurry, donor; Shades of Monterey Collection, No. 6247.)

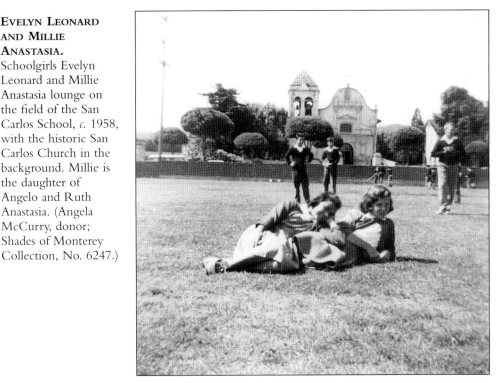

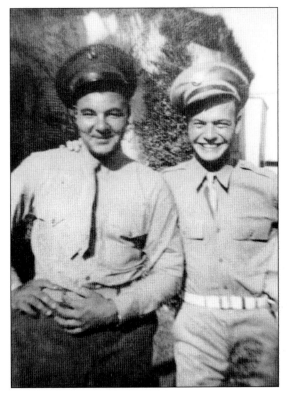

RICHARD CRUMPLEY AND BILL POST. Bill Post (left) with his brother-in-law Richard ("Dick," also called "Buster") Crumpley. Dick worked as a butcher for the Top Hat market in Pacific Grove. In this 1942 photograph Dick was AWOL from military duty in order to marry Mary Post. Bill Post (known as Bill III) was the grandson of Big Sur pioneer rancher William Brainard Post and Anselma Onesimo, who was of Rumsien Indian ancestry. (Evelyn Crumpley, donor; Shades of Monterey II, No. 6552.)

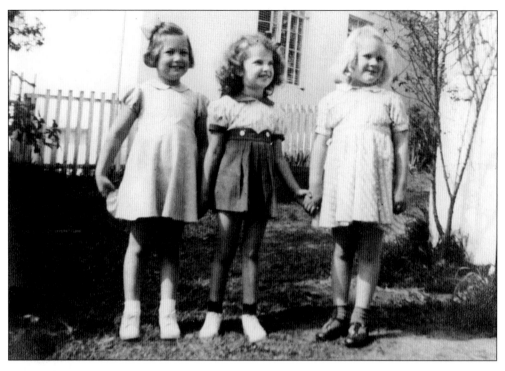

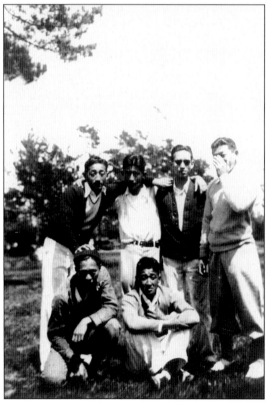

ANN GRAHAM AND ELIZABETH BEAL.
Ann Graham (center) and Elizabeth Beal
(right) are pictured at the Forest Hill
Nursery School on Pacific and Jefferson
in 1941. Ann's mother, Fay Baugh,
came to Monterey in 1915 with her
parents and lived in the predominately
Italian neighborhood affectionately
known as "Garlic Hill." (Ann
Quattlebaum, donor; Shades of
Monterey II Collection, No. 7190.)

HIGH SCHOOL BUDDIES. These 1930s
Monterey High School friends are, from
left to right, (front row) George
Takigawa and Yoshio Tabada; (standing)
James Tabata, Yoneo John Gota, George
T. Esaki, and James Turk Takigawa.
(George T. Esaki, Photographer; Jean
Esaki, donor. Shades of Monterey II
Collection, No. 7128.)

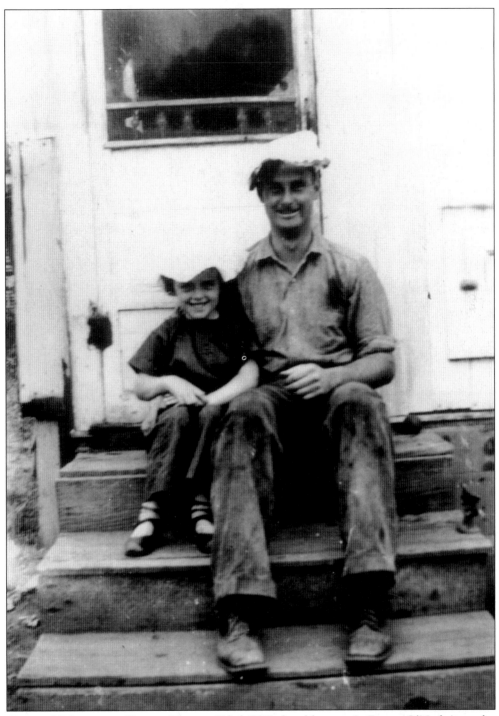

ETHEL O'NEAL AND COUSIN DANNY. Ethel O'Neal and her cousin Danny O'Neal sit on the back steps of Ethel's family home at 1250 Second Street, wearing doilies brought home from the Del Monte Hotel by their Aunt Genevieve Douglas who worked there as a maid. This photograph is dated June 1931. (Ethel Boutell, donor; Shades of Monterey Collection, No. 6145.)

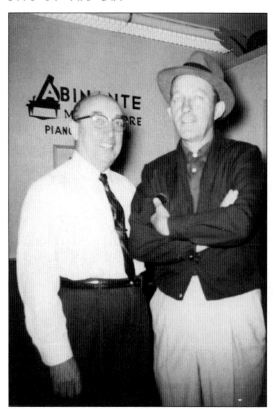

BING CROSBY AND LEO ABINANTE.
Leonard Abinante was born in Sicily and came to the United States in 1899. During World War I he toured with a troupe of entertainers and, after the war, sang for radio broadcasts. In 1930 he established Abinante's Music Store in Monterey. The store moved three times before finally settling at 425 Alvarado Street in 1939, and the store was in continuous operation by the Abinante family for over 50 years. Leonard is seen here at the store, *c.* 1950, with famous crooner Bing Crosby. Crosby sponsored an annual charity golf tournament on the Monterey Peninsula and owned a home in Pebble Beach. Leonard and his wife, Helen, raised three sons, Gene, Phillip, Robert, and a daughter, Natalie. (Natalie Whitney, donor; Shades of Monterey Collection, No. 6052.)

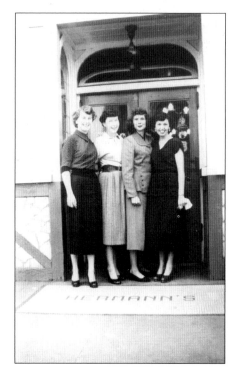

MARGANETTE BASS AND FRIENDS. Four friends gather together in front of the popular Herrmann's restaurant at 380 Alvarado Street in the early 1950s. From left to right are Maryann Wachtveitl, Marganette Bass, and two unidentified women. (Jan MacLean Jones, donor; Shades of Monterey II Collection, No. 6114.)

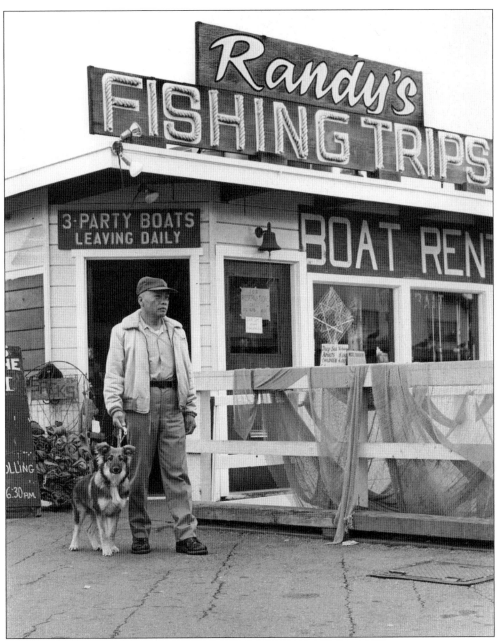

VIC CASTRO AND KING. Pictured here in 1969, Vic Castro visited Fisherman's Wharf every weekend with his dog King. "We come here every Saturday or Sunday to browse, fish and enjoy." (Harbick Collection.)

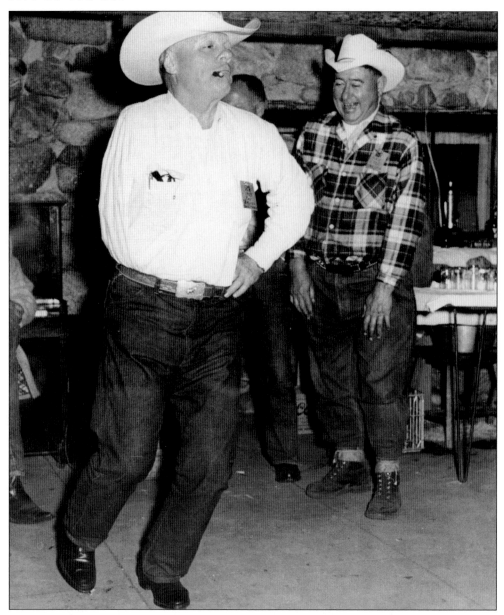

JUDGE RAY BAUGH. Dancing here at a Western-style party in the early 1950s, Judge Baugh was born in Oklahoma in 1901 and moved with his family first to New Mexico and then to Garrapata Creek south of Carmel Highlands. They came to Monterey in 1915 so that the Baugh children—Ray, Helen, and Fay—could go to school. Ray was elected municipal judge in Monterey in 1952 and was famous for his fairness. Although he never earned a law degree, in 35 years he never lost an election. Ray Baugh was a great outdoorsman and loved fishing, riding, and hunting. He lost his right arm in a hunting accident as a teen and lost his sight in his left eye in an automobile accident, but he never let it daunt him. He adapted to using his left arm and his right eye, and continued to excel in sports. In 1936, he used his left arm to hit a 135-yard hole-in-one on the Del Monte Links. (Ann Quattlebaum, donor; Shades of Monterey Collection, No. 6816.)

CHAPTER FIVE

GOOD TIMES

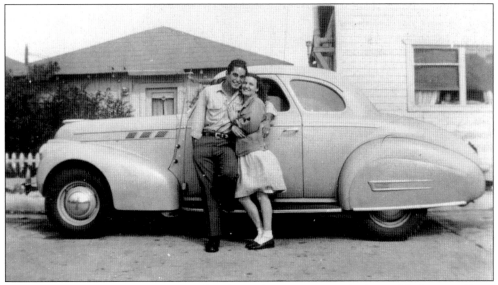

RUTH AND ANGELO ANASTASIA. Ruth and Angelo Anastasia pose in front of their car on Foam Street, *c.* 1946. The couple met at a Valentine's Day dance at the USO when Angelo was in the Navy, and they fell in love at first sight. They married and raised four children, Angela, Millie, Angelo Jr., and Joseph. This photograph is treasured by the Anastasia children as a perfect depiction of their parents' happiness together, and it appears on Ruth and Angelo's joint headstone. (Angela McCurry, donor; Shades of Monterey Collection, No. 6244.)

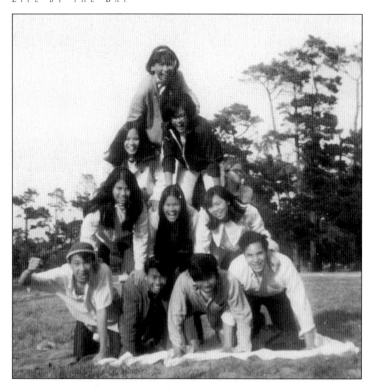

LILIA BURL AND THE HUMAN PYRAMID. Lilia (Rodriguez) Burl is on the left, in the second row from top, of the pyramid formed with friends at Veteran's Memorial Park in 1968. Her sister Lynn Rodriguez is at the top, and Miguel Rosado is on the right, on the bottom row. Lilia's father, Silverio Rodriguez, was in the U.S. Army, stationed at Fort Ord in the 1950s. He brought the family to the Monterey from the Philippines in 1956. (Lilia Burl, donor; Shades of Monterey Collection, No. 7077.)

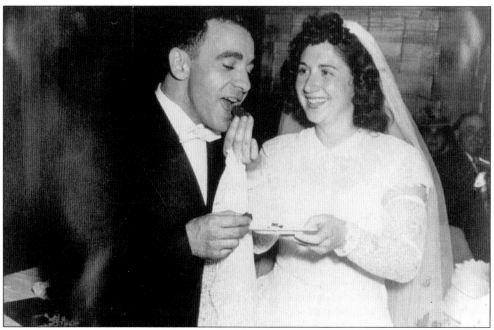

ANTHONY AND MICHELE CANIGLIA'S WEDDING. Bride and groom Michele "Lena" and Anthony Caniglia celebrate with wedding cake after the couple married at San Carlos Church on July 26, 1948. At the time of their wedding, Anthony was a pharmacist at Palace Drug Store. (Katherine DiMaggio, donor; Shades of Monterey II Collection, No. 6574.)

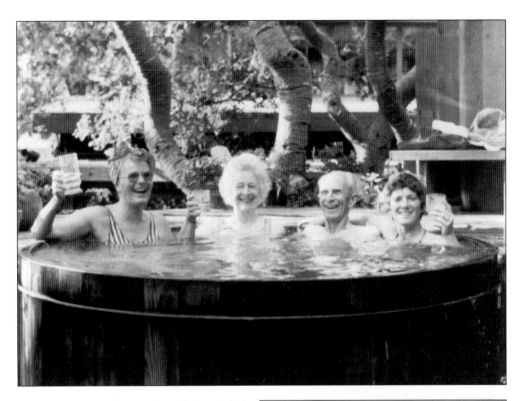

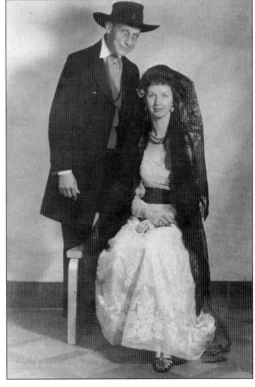

THE LEEPERS' HOT TUB. From left to right, Elizabeth Leeper, Nan Sheperd, Col. Millard Sheperd, and Dana Godbe enjoy the hot tub at the Leeper's home at 825 Lottie Street in 1979. The Sheperds were aunt and uncle of Elizabeth's husband, Ed. (Elizabeth Leeper, donor; Shades of Monterey Collection, No. 6627.)

DELBERT AND FRANCES JEFFERS AT THE CENTENNIAL BALL. Delbert Jeffers and his wife, Frances, attend the Centennial Ball in September of 1949. The event celebrated the 100th anniversary of the California State Constitutional Convention in Monterey and was held in the old Hotel Del Monte. Mr. Jeffers was the director of the Monterey Public Library from 1946 until 1951. (Joan Jeffers McCleary, donor; Shades of Monterey II, No. 7209.)

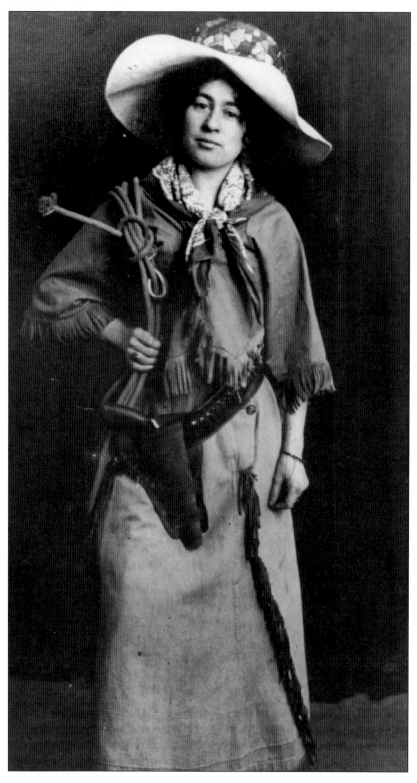

COWGIRL VICTORIA CORDERO DUARTE. Victoria (née Cordero) Duarte, pictured in cowgirl garb, *c.* 1920, is the daughter of Eddie and Susie Cordero. Her father was a blacksmith and the family lived at 727 Cass Street. Victoria married fisherman Louis Duarte. The Cordero family is descended from members of the Portola expedition in 1769 from Spain and Mexico. Other ancestors were native Esselen Indian and Italian Swiss. (Jean Cordero, donor; Shades of Monterey Collection No. 6221.)

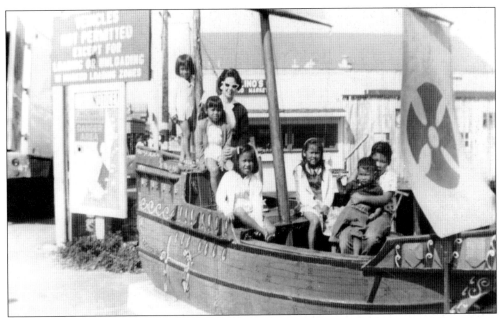

A LITTLE BOAT AT THE WHARF ENTRANCE. In the boat at the entrance of Fisherman's Wharf, in October 1961, are the Garcia siblings, from left to right, Leslie, Jean, Phyllis, Henrietta, George, and Sammy. Fran Villafuerte, wearing sunglasses, is a close friend of the family and godmother to Leslie Garcia. On her visits from her home in San Francisco, Fran, who had no children of her own, would often take the Garcia children on outings. Favorites included trips to the Wharf for taffy and feeding the ducks at El Estero Lake. (Jean Cordero, donor; Shades of Monterey Collection, No. 6209.)

PICKING HUCKLEBERRIES. Ann (née Goldsworthy) Todd; her father, Clarence Goldsworthy; and her mother's sister, Florence McKeaver, pick huckleberries on "Huckleberry Hill," located in the area of upper Prescott Street, in 1940. Clarence was born in Stockton and his family came to Pacific Grove in 1906. He married Edna McKeaver and they raised two children, Ann and John, at their home on El Caminito del Sur. Clarence was an executive at Cal Water. His wife, Edna, was a Monterey native. (Ann Todd, donor Shades of Monterey Collection, No. 6438.)

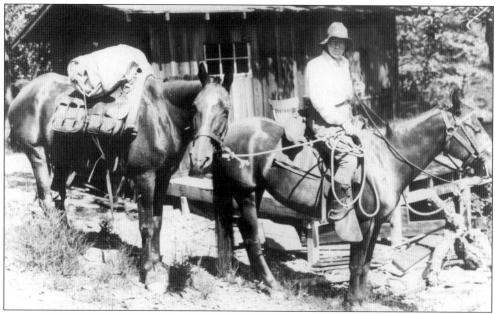

DORIS STINE MANNING. Monterey school teacher Doris (née Stine) Manning is pictured astride her horse on a pack trip to White Rock, Carmel Valley, in 1930. She went on the trip with friend Irene Ayres, and the pair camped and hunted deer. On this trip, one of the horses fell off a cliff into a box canyon. Irene rode all the way back to get a winch to get the horse out, while Doris stayed alone with the horse. This was a time when women teachers were not allowed to marry or reveal that they were married with children. These were two women ahead of their time. (Evelyn Crumpley, donor; Shades of Monterey II Collection, No. 6554.)

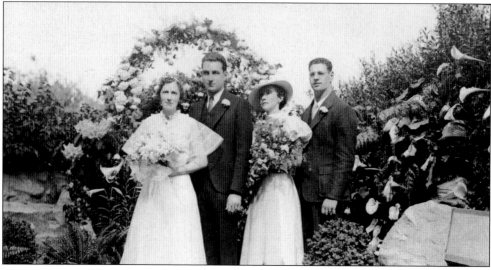

HELEN BAUGH–HOWARD MCAULAY WEDDING. From left to right are Helen Baugh (bride), Howard McAulay (groom), Fay Graham (née Baugh, Helen's sister), and Mr. D'Aquisto. The wedding took place in the backyard of Adolphus Baugh, father of the bride, on Hawthorne near Irving Street, on April 19, 1936. Howard McAulay was the son of Drs. Martin and Sarah McAulay. (Ann Quattlebaum, donor; Shades of Monterey Collection, No. 6823.)

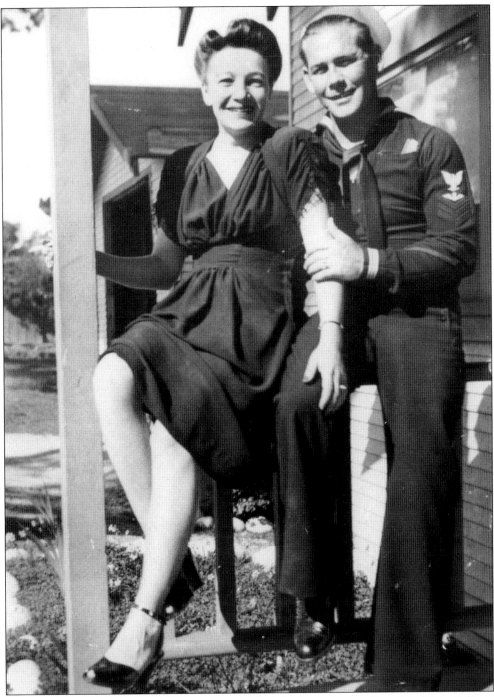

LLOYD AND ALICE McNULTY. Navy man Lloyd McNulty and wife, Alice (née Varien), show off their wedding bands in the 1940s. Alice is the daughter Alice Piazzoni and Charles Varien. After his Navy duty, Lloyd worked for Pacific Gas & Electric Company. He and Alice lived at 1270 Eighth Street in the Oak Grove area of Monterey. (Jean Cordero, donor; Shades of Monterey Collection, No. 6223.)

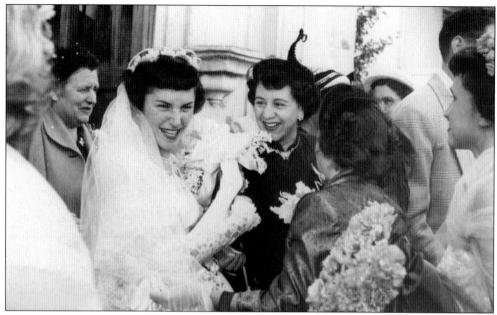

GLORIA TARALLO MERCURIO. The happy bride is Gloria Tarallo on the day of her marriage to Frank Mercurio at San Carlos Church in 1951. Frank and Gloria went to high school at the same time but didn't actually meet until afterward, when they were both attending Monterey Peninsula College. Gloria became the mother of four boys—Horace, Frank Jr., Stephen, and Daniel—as well as a real estate broker and a community volunteer. (Katherine DiMaggio, donor; Shades of Monterey II Collection, No. 6581.)

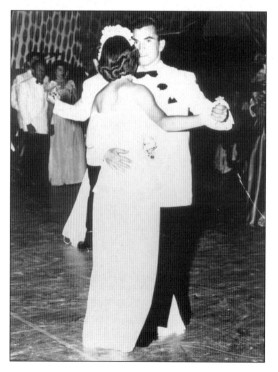

DAN ALBERT AND JOANNE VOUT. Dan Albert dances with Joan Vout at Monterey High School's 1949 prom. Joanne is wearing the prom queen's crown of flower, and in 1952, Dan and Joanne were married. Born and raised in Monterey, the son of Spanish immigrants, Dan Albert was Monterey High School's football coach and later served several terms as Mayor. Joanne is the daughter of business leader and civic activist Murray Vout. (Dan Albert, donor; Shades of Monterey II, No. 7216.)

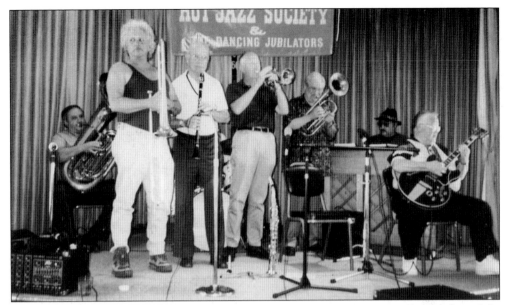

MONTEREY BAY HOT JAZZ SOCIETY AND THE DANCING JUBILATORS. From left to right are musicians Dick Gularte, Steve Schulsser, Dave Bush, Carl Riley, Joe Ingram, unidentified, and Len Williams on stage at the Moose Lodge *c.* 1990. The group, formed around 1975 by musicians dedicated to playing jazz, performed regularly at dances held at the Moose Lodge Hall. (Dave Bush, donor Shades of Monterey Collection, No. 6033.)

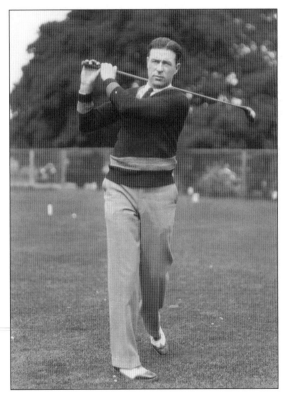

LEFTY O'DOUL. Lefty O'Doul tries a different kind of swing at the Del Monte Golf Course in 1928, and the following year led the National League in batting with 254 hits. Born in San Francisco, he was beloved by San Francisco and California baseball fans, second perhaps only to Joe DiMaggio. Across from the Hotel del Monte was the Del Monte Golf Course, which was renovated in 1911 with new greens and fairways and was laid out with 18 holes. The course remained until the coming of the Highway 1 freeway. (Julian P. Graham, photographer; Harbick Collection.)

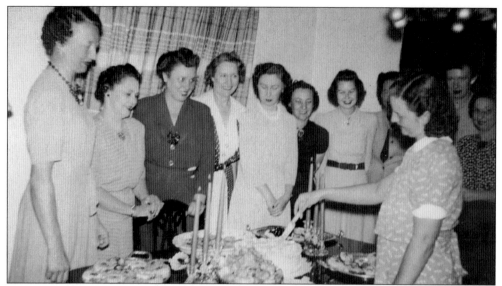

WILLA PREGO'S BABY SHOWER. Willa "Billie" Prego, expectant with her youngest daughter Linda, cuts the cake at her baby shower in October 1942. From left to right are Marie Harris, Jean Keeley, Mrs. E. Hilby, Mrs. Smith, Virginia Brown, Mary Darling, Arlene Steward, Eunice Trenner, Blanch Keeley, Vera Keeley (hostess), and "Billie" cutting the cake. Willa (née Lucas) came to Monterey from Parnell, Missouri, in 1925 and married Andy Prego, son of Spanish immigrants Andreas and Angelita Prego. Willa took over her mother-in-law's job as caretaker of the Cooper-Molera Adobe, when it was still owned by Frances Molera. (Linda Thorpe, donor; Shades of Monterey II Collection, No. 6507.)

MR. AND MRS. WILLIAM IRVINE. On July 10, 1965, at high noon, Mr. and Mrs. William Irvine repeated their wedding vows in the San Carlos Church where they were wed 50 years before. The bride's maid of honor was her sister Rose Silveira (who later became Mrs. Rose Carmody). (MacDougall King, photographer; Harbick Collection.)

ROBERT AND MARCIA FRISBEE DEVOE. Newlyweds Robert and Marcia Frisbee DeVoe stand under the 1887 trellis of St. John's Episcopal Chapel on August 8, 1944. The trellis stood at the main gate to the church. (Courtesy of Marcia DeVoe; Historic Photo No. 3710.)

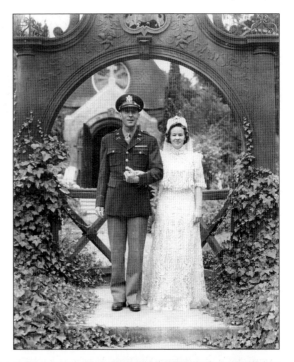

MONTEREY'S 1948 GOLD RUSH. On January 10, 1948, almost 100 years after the discovery of gold in California, a bulldozer unearthed several $20 gold pieces buried under the foundations of an old house. The Martin house, which had belonged to pioneer Will Martin, who did not trust banks, was being moved for a new high school music building. Some 400 gold pieces worth $8,000 were uncovered in three or four days by feverish gold seekers. Some coins dated to the 1870s. One of the lucky miners, Edith Perry, shows off her find. (Fred Harbick, photographer; Harbick Collection.)

ANN AND NANCY PREGO. Ann Prego (left) and her sister Nancy display their dresses for Monterey Union High School's annual Winter Ball held on December 18, 1954. Their mother, Willa, made the girls' gowns on her Singer treadle sewing machine. (Ann Prego, donor; Shades of Monterey II, No. 6317.)

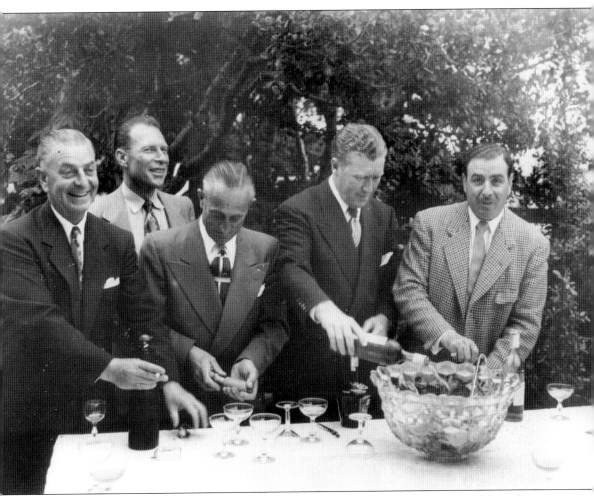

WEDDING ANNIVERSARY. Clarence and Edna Goldsworthy's 50th anniversary is celebrated at the family home at 24 El Caminito del Sur in August 1952. Refreshing the punch bowl are, from left to right, Clarence Goldsworthy, Ted McKay, Rowland Ingles, Robert McKeaver Jr., and Sal Cerrito. The Goldsworthys' daughter Ann reported that it must have been a pretty good party because the guests were falling into the bushes as they left. (Shades of Monterey, No. 6440, donor Ann Todd.)

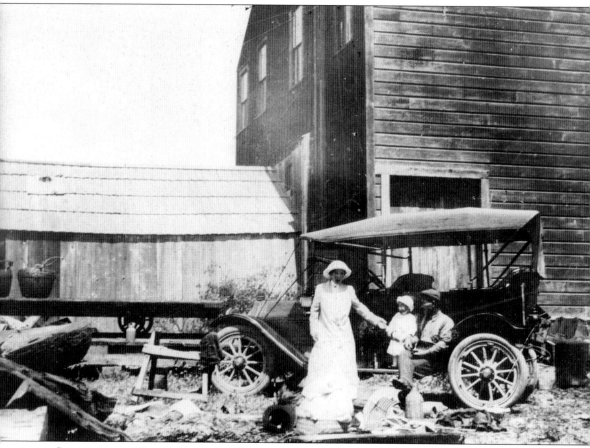

IKUTARO AND MATSU TAKIGAWA PICNIC WITH GRANDSON. Ikutaro and Matsu Takigawa set up a picnic with their young grandson George in 1916. Ikutaro, a respected elder in the Japanese community, was an abalone fisherman who co-owned, with Tonosuke Esaki, the Coast Abalone Processors on Fisherman's Wharf. (William Takigawa, donor; Shades of Monterey Collection, No. 6336.)

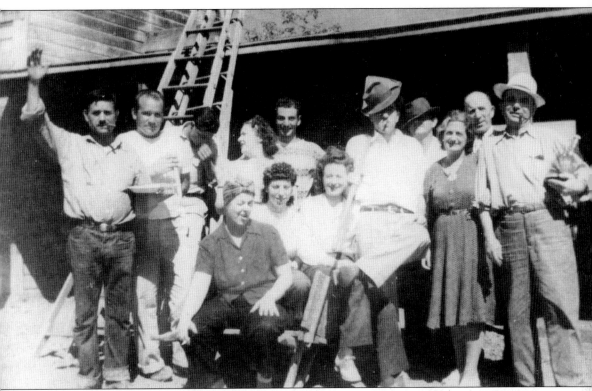

RESTAURANT GROUP. A group of employees from a local restaurant celebrate in this 1946 photograph. Grace C. Turnbull is holding the pole in the center of the image. (Marge Turnbull, donor; Shades of Monterey Collection, No. 6653.)

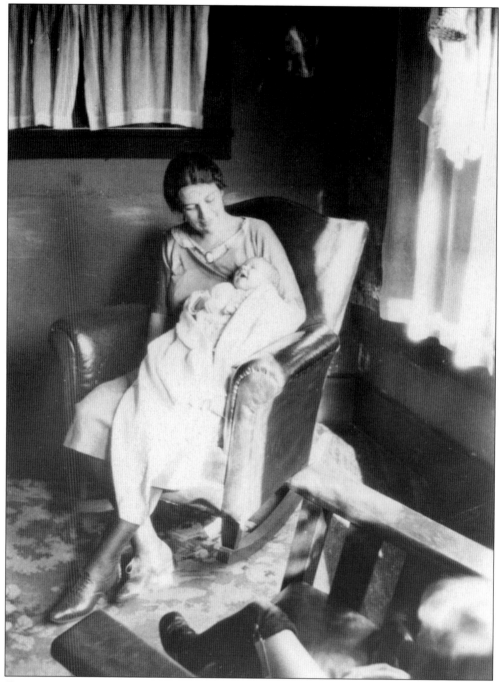

Bessie and Mary Lou Gartshore. Bessie Gartshore holds her newborn daughter Mary Lou in their living room at 875 Fillmore Street in 1923. Her daughter Jane is in the right foreground wearing the over-the-knee stockings and garter. Bessie came to Monterey in 1918 from Santa Ana, California, and she worked as a waitress at the Hotel del Monte. She married John Gartshore, who came from Glasgow, Scotland, in 1917. (Bonnie Gartshore, donor; Shades of Monterey Collection, No. 6203.)

HOME AND FAMILY

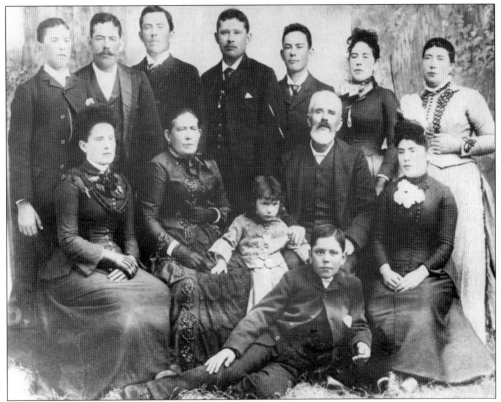

THE DUARTE FAMILY. Rosario Duarte, born in Santiago, Mexico, came to Monterey in 1849 where he became proprietor of the Washington Hotel and operated a fishing and general merchandise store. He married Maria Altagracia de la Torre, daughter of Jose Joaquin de la Torre, at Mission San Carlos. Their sons Lewis and Manuel Duarte continued in the fishing business, operating at various times a ship's chandlery and fish market across from the Custom House and, at one time, a fleet of 20 fishing boats. They had 10 children: sons Frank, Lewis, Manuel, Santa Maria, Esperion, and Ygnacio; and daughters Maria Altagracia, Maria, Josefa, and Rufena. The brothers and sisters operated various stores on lower Alvarado Street near the wharf, including a barber shop, cigar store, grocery, "Cannery Boat House," fish market, and boat rental. (Historic Photo No. 2074.)

EDNA ANTHONY. Edna (née Wright) Anthony crochets in her Larkin Street apartment in the 1950s. Born in Iowa in 1878, Edna came to California as a small child and was raised in Contra Costa County. Her parents, officers in the Salvation Army, brought her to Pacific Grove during summers to participate in the Chautauqua educational encampments. She moved to the Peninsula in 1900 when she married her husband J.C. Anthony, a prominent builder who left a legacy of distinctive chalk rock buildings and restorations. Edna was interested in the preservation of old adobe buildings, active in community affairs including the Serra Pilgrimages in the 1920s, and one of the founders of the County Fair and the Women's Civic Club. (Jan MacLean Jones, donor Shades of Monterey II Collection No. 6134.)

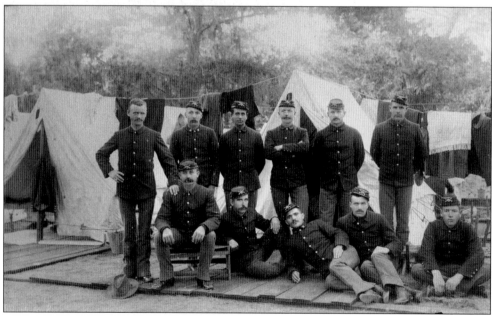

COMPANY B. Company B, 1st U.S. Infantry are at home in Camp Monterey, not far from the Hotel del Monterey, in this photograph taken July 12, 1890. (C.W.J. Johnson, photographer; Historic Photo no. 4863.)

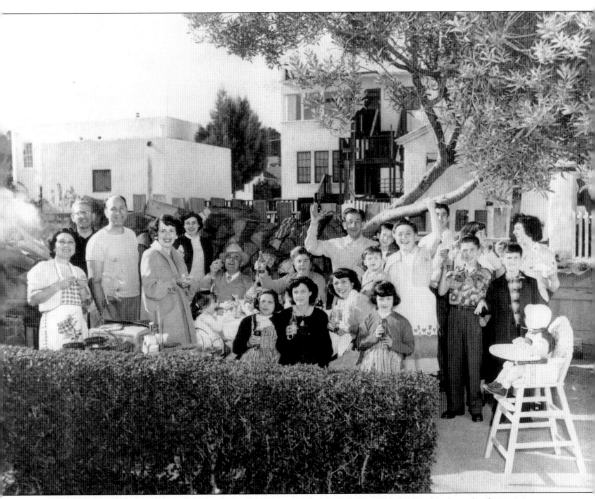

THE MERCURIO FAMILY BARBECUE. Family and neighbors gather in the backyard of Horace (second from the left) Mercurio's home, at 308 Watson Street, to celebrate his birthday with a barbecue. Fourth from the left is Horace's daughter Katherine and on her left is her husband, Frank DiMaggio. In the sardine fishing heyday of the 1930s and 1940s, Horace was the owner of the purse seiner *El Rey*. He later went into the insurance business with his son-in-law Frank DiMaggio. Horace was active in community affairs and served on Monterey's City Council from 1947 through 1951. He was married to Rose (née Lucido) seen here sixth from right, waving and wearing an apron. The child in the high chair is the son of Mamie (née Colletto), far right, and Lee Blaisdell. (Lee Blaisdell, photographer; Katherine DiMaggio, donor. Shades of Monterey II, Photo No. 6573.)

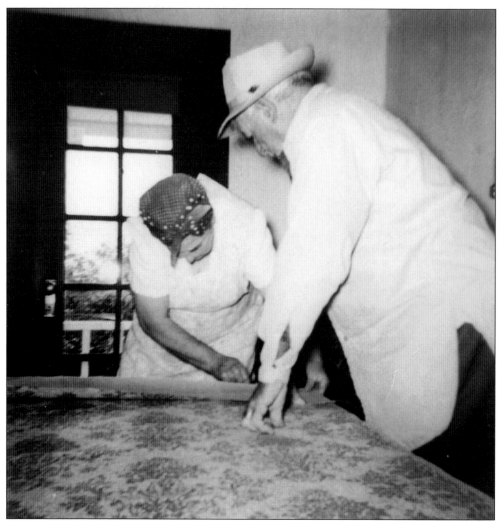

BESSIE AND JAY EDGARTON. Bessie and her husband, Jay Edgarton, tackle a wallpaper job in the family home at 875 Fillmore Street, *c.* 1950. Bessie married Jay after being widowed by her first husband, John Gartshore, father of her three daughters, Jane, Mary Lou, and Bonnie. (Bonnie Gartshore, donor; Shades of Monterey Collection, No. 6152.)

BOBBIE BARONE AND ANGELA ANASTASIA.
Bobbie Barone holds her god-daughter
Angela Anastasia following Angela's baptism
at San Carlos Church in 1952. Bobbie
Barone is Angela's older cousin, the daughter
of Angela's mother's sister. (Angela Anastasia
McCurry, donor; Shades of Monterey II
Collection No. 6949.)

MARIANNE ORTINS. Marianne Ortins (in
hat) works in her garden at the family
home at 478 Larkin Street, *c.* 1900.
Marianne came to Monterey from Portugal.
Her husband, Manuel, was a whaler and
later owned a grocery store on Alvarado
Street. (Anthony Moltini, donor; Shades of
Monterey Collection, No. 7011.)

89

THE KIRBY FAMILY. The Kirby family poses in front of the family home at First Street and Ocean Avenue in 1943. From left to right are (front row) children Alan, Richard, Robert, and James; (back row) Joseph Kirby Jr., Joseph Kirby Sr., and Dorothy Kirby. The Kirby ancestry includes Irish men and women who immigrated in the 1850s and Germans who settled in New York and New Jersey. Dorothy's (nèe Emigh) family were English and Germans who originally settled in Pittston, Pennsylvania. (Robert Kirby, donor; Shades of Monterey, No. 6617.)

JOHN STEINBECK. John Steinbeck holds son Thom for his christening at St. James Episcopal Church, then located on Pacific Street, in this March 1945 photograph. The church was later moved to Van Buren to become Monterey History and Art Association's Mayo Hayes O'Donnell Library. Steinbeck had returned to Monterey, bringing his wife, Gwyn, and baby Thom to live in the old adobe he had long admired— the Soto House. There he wrote much of the novel, *The Pearl*. (Harbick Collection.)

THE KODAMA FAMILY. This family portrait of Setsuji Kodama, a prominent leader in the Japanese community, stands with his daughter Rose and wife, Fujiko, in 1922. Setsuji was born in 1886 in Hiroshima, Japan, and came to America when he was 16. He returned to Japan in 1914 to marry Fujiko Nagatani. The couple settled in Monterey and entered into a partnership in a wholesale fish business. In 1920, they opened the Owl Cleaners, a dry cleaning service. The Kodamas had seven children. The three eldest, including Rose, died in childhood. The family home was at 330 Watson Street. (George Kodama, donor; Shades of Monterey, No. 7022.)

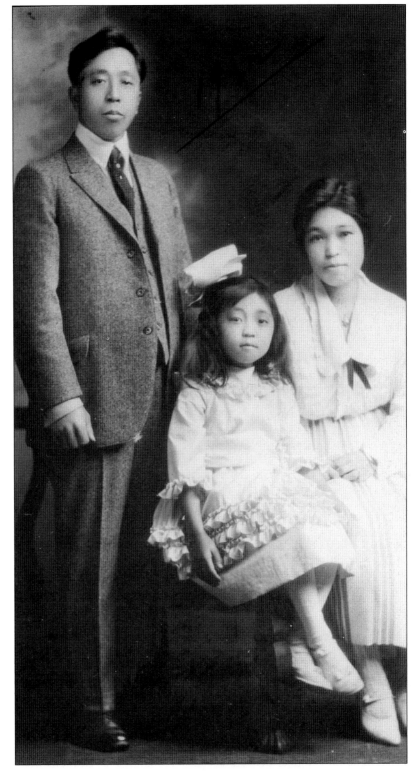

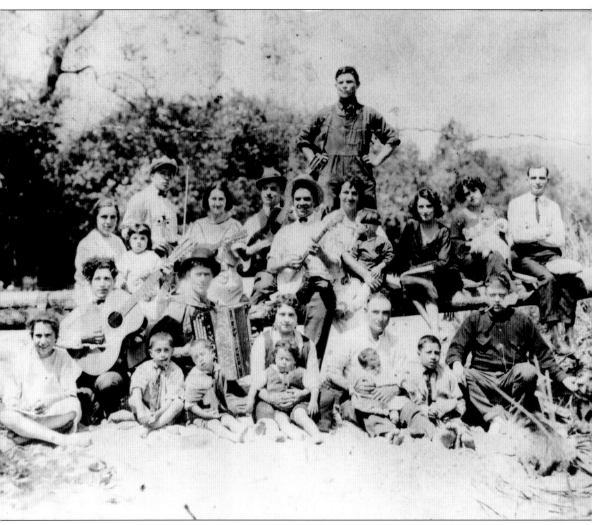

BOTTARO FAMILY PICNIC. This large group gathered to celebrate the christening of Carmen Bottaro in the 1920s. Nick Marotta, holding the guitar, was born in Tunisia in 1903 and came to Monterey by way of Canada at age 16. His siblings Vince, Mary, Mario, Tony, and Emma all played instruments and sang, and no baptism, wedding, or celebration was complete without them. On Sundays the family would often go to the beach for a picnic to sing and play. They would take wine and bread, and then find sea urchins, crack them open, sprinkle lemon juice on them, and have a feast. (Laurie Hambaro, donor; Shades of Monterey Collection, No. 6058.)

MANUEL AND FELICIANA SOTO.
Manuel Soto and his wife, Feliciana, stand proudly outside their Lara–Soto Adobe home on Pierce Street about 1895. The house is now a part of the Monterey Institute of International Studies campus. Manuel Lara-Soto, born to Jose Ygnacio Soto and Maria de Jesus Lara-Zabela in 1828, was a well-known local woodcutter and barber. Feliciana, a Gabrieleño Indian from southern California, was born in 1829. (J.K. Oliver, photographer; Historic Photo No. 4475.)

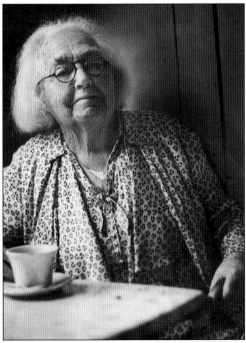

HARRIET SARGENT GRAGG. Harriet Sargent Gragg, known to most Montereyans as Hattie, sits in the kitchen of her Hartnell Street home, the Stokes-Escolle Adobe. This 1947 photograph was taken about the time of Hattie's 90th birthday, when Monterey celebrated its distinguished old-timer with a grand birthday party. Born in 1857, Hattie grew up in Monterey and on the Rancho San Carlos in Carmel Valley. She was a founder of the Monterey Civic Club, an active member of the Monterey History and Art Association, and a civic activist who campaigned to have old Monterey landmarks preserved. She remembered racing the Del Monte Express train on horseback as a young girl, watching Indian women washing clothes in Washerwoman Gulch, and attending dances and parties. She told vivid stories and anecdotes of a Monterey when only Spanish was spoken on the streets and playgrounds. (Willa Perceval, photographer; Harbick Collection.)

93

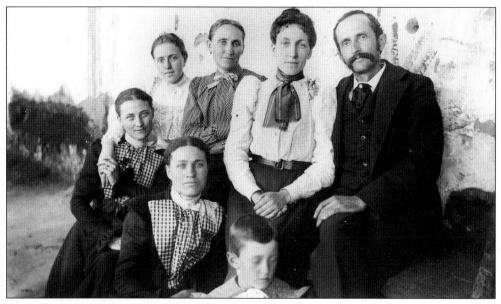

THE OLIVER FAMILY. The Olivers sit for a photograph at the Custom House about 1899. Joseph K. Oliver and wife, Mary Annis, are on the right. Next to Mrs. Oliver are her mother, sister, and nieces. Seated in front is their young son Myron Angelo Oliver. In 1893, Joseph Kurtz Oliver brought his family from Kansas to the Monterey Peninsula. A painter and art teacher, Oliver opened the first art supply and framing shop in Monterey opposite the Custom House. In 1902 he added the first art gallery where works of local painters could be exhibited. His son Myron Oliver, an artist and art patron, carried on the business. Graduating from Stanford University in 1915, Myron studied art on the East Coast, followed by training with famed artist Armin Hansen. Returning to Monterey, he presided over the Carmel Art Association and worked with fellow artists to restore some of the original adobes. With Charlton Fortune, Francis McComas, and other artists, he was a key figure in the Monterey Guild. (J.K. Oliver, photographer; Oliver Collection, No. 4456.)

DES CORMIER FAMILY. From left to right are Bernadette and Ludger Des Cormier, their daughters Joan and Yvonne, and two World War II roomers who rented living quarters in the family home at 1173 Franklin Street, c. 1943. Ludger was a machinist and worked at the Hovden Cannery, among other jobs he held over the years. (Yvonne Ashmore, donor; Shades of Monterey Collection, No. 6412.)

THE MORRIS FAMILY CHRISTMAS. The Morris family poses in the family home on Alameda Street on Christmas, *c.* 1955. From left to right are J. Richard Clements Sr., Derek Morris, Peggy Morris, and Irene Clements. Derek is the son of Peggy, a kindergarten teacher, and the Clements are Peggy's parents. (Meg Morris, donor; Shades of Monterey, No. 6833.)

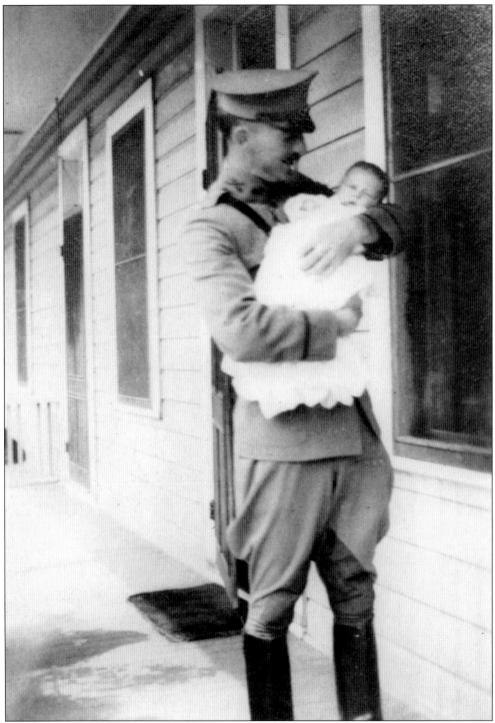

CAPTAIN STILLINGER AND SON. Captain Otto Stillinger holds his infant son Dudley at the Monterey Presidio, *c.* 1922. Dudley's mother is Flora Loomis Stillinger. (Jane Stillinger, donor; Shades of Monterey, No. 6926.)

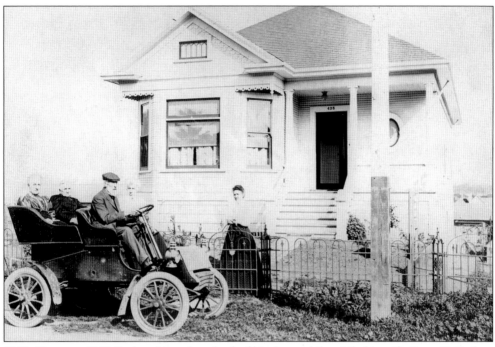

E.K. BARKER. E.K. Barker sits at the wheel of his automobile while his wife, Sarra C. Barker, stands at the gate to their home at 425 Van Buren, *c.* 1910. Mr. Barker was a commercial photographer in Monterey. (Historic Photo No. 5043.)

TONI AND CLARA BRUCIA WITH NANA. On the left is Toni Brucia, with her sister Clara on their day of their First Communion in 1928. The family could not afford to buy the white shoes that are traditionally worn, so they "painted" the children's dark shoes for the occasion. In the center is their mother Guiseppina "Nana" Brucia. The photograph was taken in the family's apartment on Pacific Street. Guiseppina and her husband, Antonio, helped advise Italian immigrants on citizenship and other legal matters. During the Second World War, Guiseppina held an open house on Thursday nights and served spaghetti and meatballs to draftees. (Toni Brucia, donor; Shades of Monterey II Collection, No. 6343.)

JOHN, JENNIE, AND JOSEPH ANASTASIA. John Anastasia with his parents, Jennie and Joseph Sr., are seated around the kitchen table in the family's home at 888 Pacific Street in 1954. Jennie (née Ganguzza) was born in Italy, and at the age of 12, she was sent to New Jersey, where she grew up with a large group of step-sisters. She was happily wed to Joseph Anastasia in a marriage arranged by the families. Her granddaughters remember her as a kind and intelligent woman who was a great cook, knitted beautiful sweaters, and gave sage advice. (Angela Anastasia McCurry, donor; Shades of Monterey II Collection, No. 6947.)

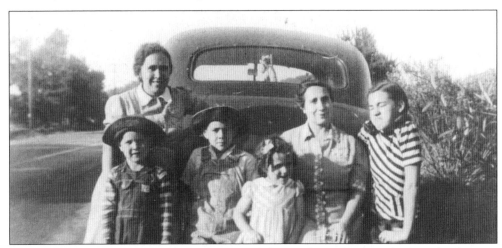

THE GONZALES AND CASAS FAMILIES. From left to right are Bienvenida Gonzales, her son Andy, Frank Casas, Marcelina "Margie" Gonzales, Fermina "Minnie" Casas, and Consuela "Connie" Gonzales. Sisters Bienvenida and Fermina were born in Mancera de Abajo, Salamanca, Spain to Tomas Andres and Marcelina Turnes. In 1913, seven-year-old Minnie accompanied her parents to Hawaii and, the following year, to Hollister. The family returned to Spain in 1918 to get Bienvenida, by then age 10, who had stayed behind with her grandmother. In 1928, Bienvenida married Fernando Gonzales, who came from Navales, Salamanca, Spain, in 1918 to live with relatives in Watsonville. Before moving to Monterey, the couple lived in Hollister, worked on ranches, and traveled to various California cities to do seasonal work in canneries. (Ann Prego, donor; Shades of Monterey II Collection No 6319.)

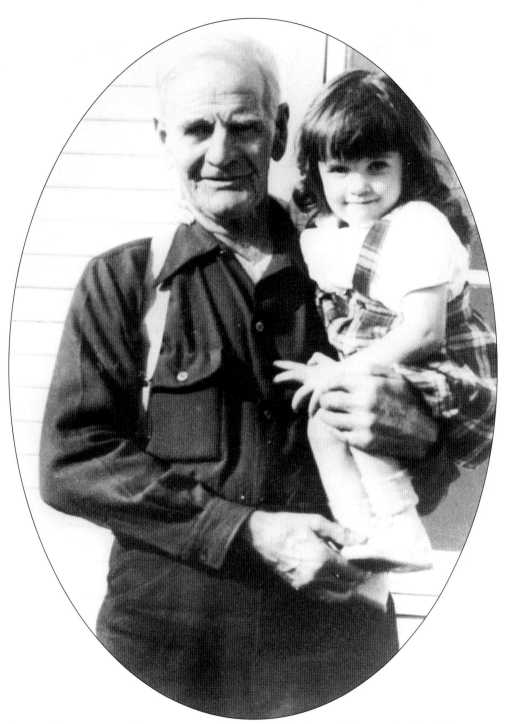

Linda Prego with Grandfather. Linda Prego is pictured here at the family home on February 17, 1946, with her beloved grandfather, Orron Lucas, the father of Linda's mother, Willa Lucas Prego. Orron lived in a nearby unincorporated area, now part of Sand City. (Linda Thorpe, donor; Shades of Monterey II, No. 6508.)

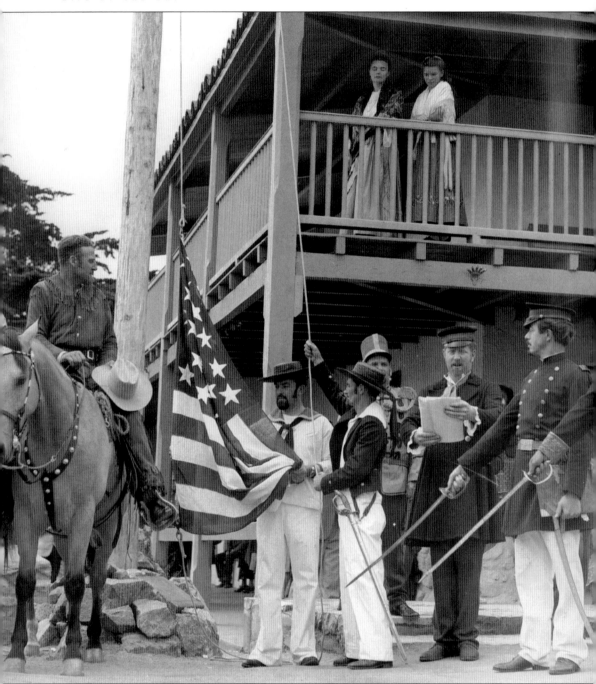

RE-ENACTMENT OF THE RAISING OF THE AMERICAN FLAG IN MONTEREY. During the centennial of the 1849 California Constitutional Convention, players re-enacted the raising of the American flag over Monterey at the Custom House. In June 1846, American sailors under the command of Commodore Sloat took the capital of Alta California, Monterey, from the control of the Mexican government and declared California a part of the United States. (Willa Perceval, photographer; Harbick Collection.)

MONTEREY
CELEBRATES

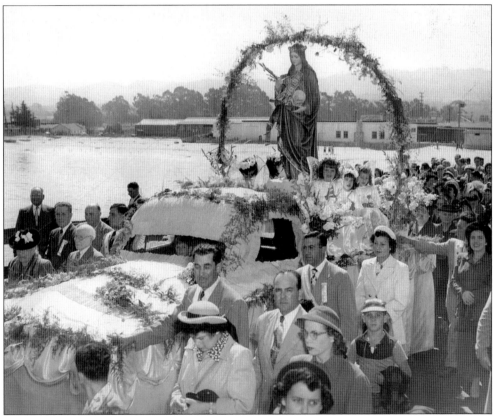

SANTA ROSALIA FESTIVAL. Following a High Mass, Catholic fishermen, their families, and friends processed behind a platform carrying the statue of Santa Rosalia to the wharf where the bishop blessed all the boats and crews for safekeeping. The statue of Santa Rosalia of Palermo, Sicily, is the protector of fishermen and sailors. When the people of Sicily came to Monterey they brought the tradition of Santa Rosalia and her festival, as seen in this procession on a Sunday in September 1950. (William L. Morgan, photographer; MO1259A.)

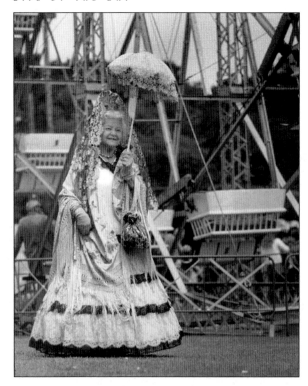

MARGARET CASTRO. Margaret (Mrs. Tony) Castro, a member of one of Monterey's oldest families, wears an authentic Spanish dress. Born and reared in the Monterey area, she exhibited her collection of costumes during the Monterey County Fair in 1969. Her grandfather was Pedro Artellan, coxswain at the Custom House during the 1800s. (Roger Fremier, photographer; Harbick Collection.)

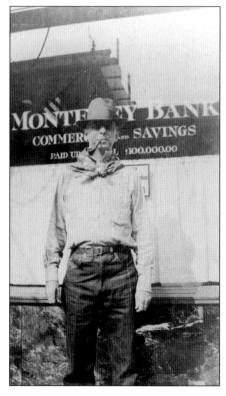

E.E. JAMES DRESSED FOR THE COUNTY FAIR. Banker E.E. James stands in front of 452 Alvarado Street dressed in costume for the county fair, *c.* 1940. In the early days of the fair, which began in 1933, everyone dressed in costumes recalling Monterey's old days. It seems that the whole town got into the playful spirit of the event. In 1936 it was reported that anyone caught out of costume would be "arrested" and "sentenced" to a few minutes in "the cooler," a large roped-off area of the downtown. (Edith James Karas, donor; Shades of Monterey Collection, No. 6011.)

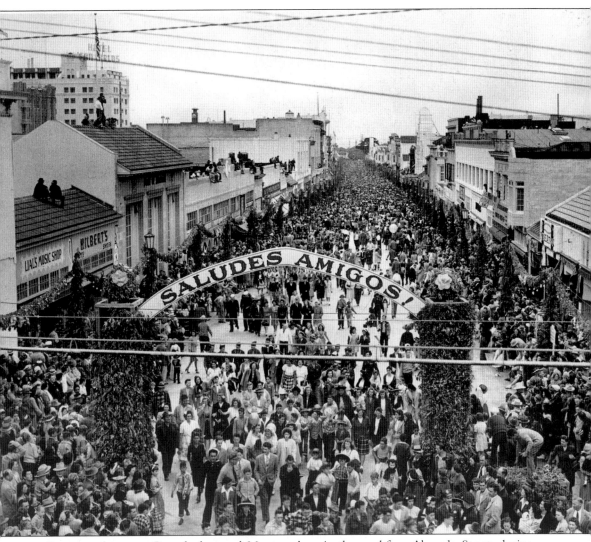

SALUDES AMIGOS. Crowds thronged Monterey's main thoroughfare, Alvarado Street, during the 1949 centennial celebration. The theme of the centennial, celebrating the constitutional convention of 1849, was the "Beginning of Statehood." Alvarado Street was painted gold for the occasion. (Rey Ruppel, photographer; Harbick Collection.)

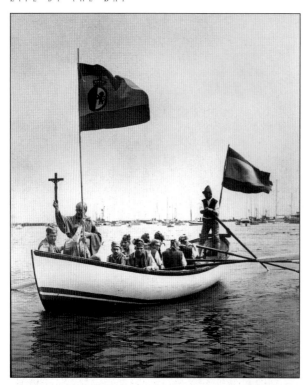

RE-ENACTMENT OF FRA SERRA'S LANDING. To commemorate the founding of the 200-year-old city, Fra Junipero Serra (portrayed by Father George McMenamin) and party dramatically re-enact Serra's landing and the blessing of Monterey on June 3, 1770. Serra, arriving by sea, and Don Gaspar de Portola, arriving by land, met on the shores of Monterey Bay, and there the first Mass was celebrated. This photograph is dated June 1970. (Patricia Rowedder, photographer; Harbick Collection.)

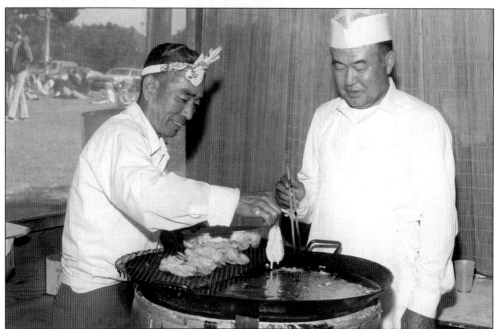

OBON FESTIVAL. Al Ito and Frank Yorita cook shrimp tempura in a massive wok at the Obon Festival in August 1973. The annual Obon Festival, a Buddhist memorial for the departed and a thanksgiving service for the living, is sponsored by the Japanese-American community. (MacDougall King, photographer; Harbick Collection.)

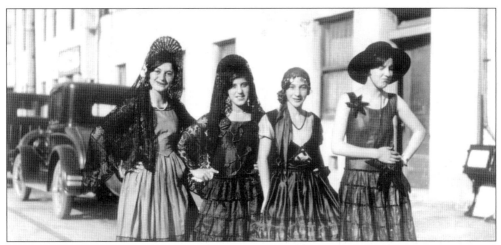

GIRLS AT SERRA PILGRIMAGE. From left to right, Anne Lucido, Rose Berry, Mary Darling and Daphne (?) are dressed in Spanish costume to celebrate the 1926 Serra Pilgrimage, an event commemorating the founding of the San Carlos Cathedral in Monterey and Mission Carmel (San Carlos Borromeo). The celebration passed into history sometime in the 1960s. (Anne Lucido Orlando, donor; Shades of Monterey II Collection, No. 6562.)

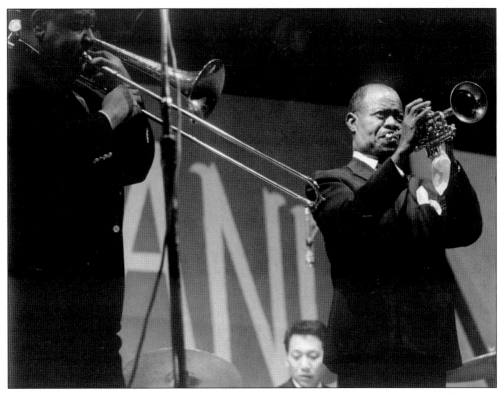

DIXIELAND FESTIVAL, 1968. Headlining the first annual Dixieland Festival, held at the Monterey County Fairgrounds on May 10, 1968, was Louis Armstrong with his All Stars. "Satchmo" thrilled the audience with his rendition of "Hello, Dolly." (MacDougall King, photographer; Harbick Collection.)

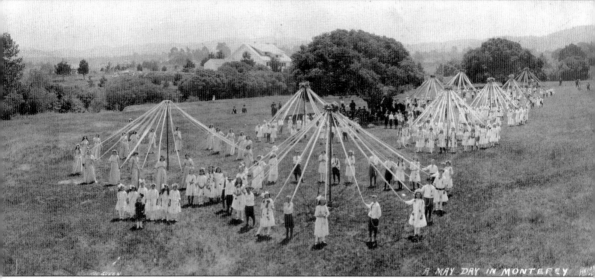

A TRADITIONAL MAY DAY IN MONTEREY, 1923. Both the audience of parents and friends and the Maypole dancers pause as photographer Anton Heidrick takes this amazing panorama of the festivities. Early May Days in Monterey featured a parade of two or three bands, which marched up to the tract of land behind the Monterey public school. There six or more May

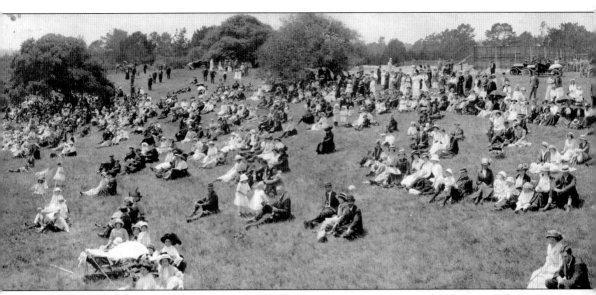

poles were erected. Eighteen to twenty children, dressed in costumes representing different countries, would weave in and out with colored streamers at each pole as they kept time with the music. (Panorama Collection, No. 1371.)

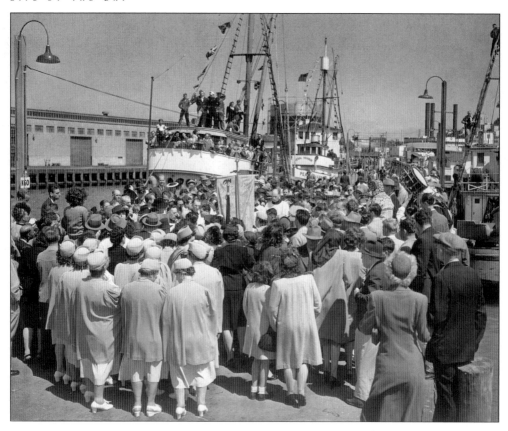

BLESSING OF THE FLEET. Crowds of Monterey's fishing families and friends listen to the blessing of the fishing fleet at the wharf during the 1949 Santa Rosalia Festival. (Harbick Collection.)

LEON PANETTA IN FOURTH OF JULY PARADE. Congressman Leon Panetta waves at spectators along Monterey's Fourth of July Parade route in 1990. Panetta, who served eight terms in the U.S. Congress and served as President Bill Clinton's chief of staff, was the grand marshal of the parade, the first Fourth of July parade held in Monterey in 30 years. (Joe Johnson, donor; Shades of Monterey Collection, No. 6600.)

TEA IN THE HISTORIC LARKIN HOUSE. Docents serve tea in the historic Larkin House, built in 1834, during the Monterey History and Art Association's Adobe Tour, July 1956. The dining room was originally U.S. Consul Thomas Larkin's reception room. (Historic Photograph No. 3086.)

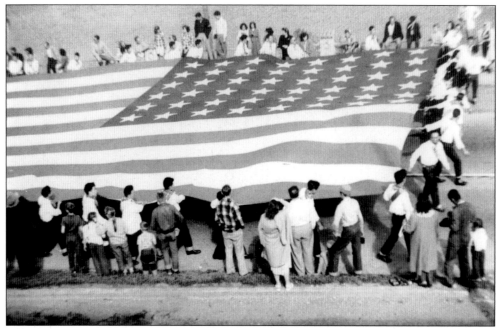

JAPANESE-AMERICAN CITIZEN'S LEAGUE IN CENTENNIAL PARADE. Members of the Japanese-American Citizen's League (JACL) carry a giant flag in the 1949 Centennial Parade, celebrating the anniversary of California's Constitutional Convention. The 40-foot-by-70-foot flag was made in 1937 by JACL's women's auxiliary and 60 people were required to carry it. This photograph was taken by George T. Esaki. (Jean Esaki, donor; Shades of Monterey II Collection, No. 7139.)

KITTY RAGSDALE AND JOSEPHINE SIMONEAU FUSSELL. Grandly costumed ladies Katherine "Kitty" Ragsdale (left) and Josephine Simoneau Fussell descend the stairs at the 1966 Baile de los Cascarones, sponsored by the Monterey Civic Club. Mrs. Fussell was chosen as honored guest of the annual event. As a child, she used to sit on Robert Louis Stevenson's knee when he came to visit her father, Jules Simoneau. Mrs. Ragsdale was president of the Monterey Civic Club. The Cascarones Ball refers to the "cascarones," the beautifully decorated eggshells filled with tiny bits of colored paper and sometimes perfume, perhaps gold dust, which were gently crushed over the heads of senoritas at the ball. (MacDougall King, photographer; Harbick Collection.)

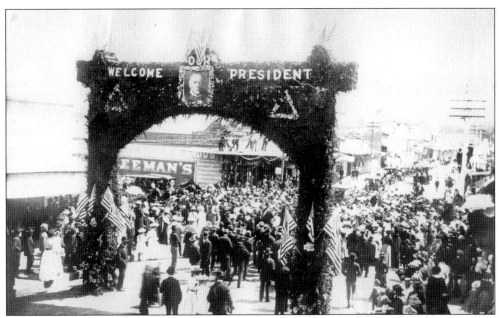

PRESIDENT MCKINLEY IN MONTEREY. Monterey crowds gather on Alvarado Street to see and hear President William McKinley during his goodwill tour of 1891. (Historic Photo No. 1917).

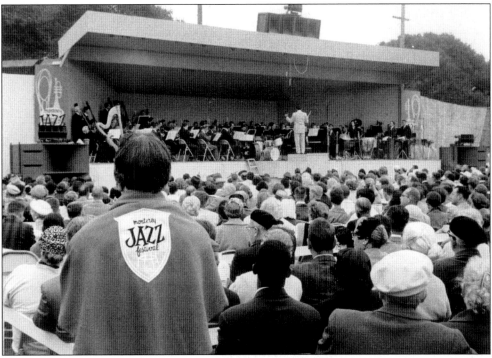

THE FIRST MONTEREY JAZZ FESTIVAL. A crowd gathered for the Sunday afternoon performance of the first Monterey Jazz Festival on October 5, 1958. Gregory Millar conducted the 80-piece Monterey Jazz Symphony, sharing the bill with Dave Brubeck's Quartet and the Modern Jazz Quartet. (Vestal, photographer; Harbick Collection.)

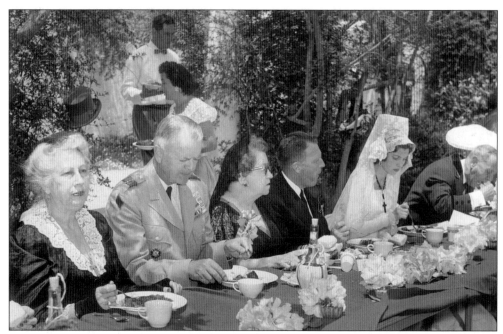

THE JUNE 1958 MERIENDA. Honored guests at the 1958 Merienda included Anita Doud, Maj. Gen. William Breckinridge, Mayo Hayes O'Donnell, Rear-Adm. Elmer E. Yoemans, and La Favorita, Diana Davison. La Favorita, selected from one of Monterey's old families and dressed in a Spanish gown and mantilla of heirloom lace, reigns over the celebration of Monterey's birthday held annually in Memory Garden. (George Smith, photographer; Harbick Collection.)

LISA AND TERRY KAZUTO. The Kazuto sisters—Lisa, age 5, and Terry, age 7, of Salinas—wear Japanese kimonos during the October 1973 Obon Festival. The "Gathering of Joy" includes such displays of Japanese culture as dances, tea ceremonies, painting, art, exhibitions, games, and food. (MacDougall King, photographer; Harbick Collection.)

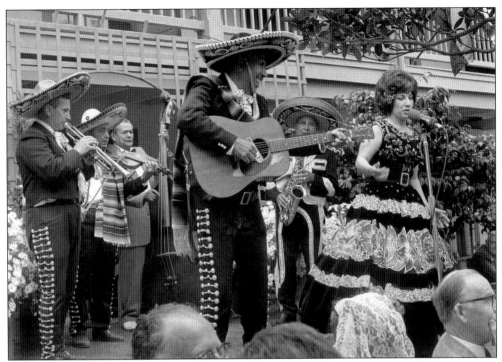

THE ANNUAL MERIENDA. In the Memory Garden of the Pacific House, Manuel Campos and his band play and Panchita Mendoza sings songs of Mexico and Spain for the 1969 Merienda, a feast celebrating the 199th birthday of Monterey. (MacDougal King, photographer; Harbick Collection.)

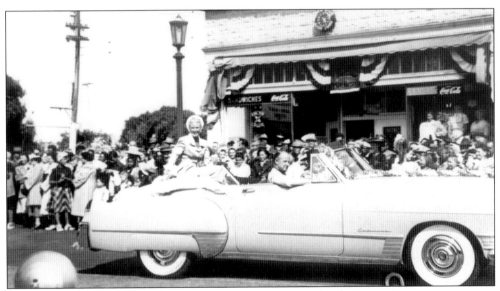

GINGER ROGERS IN CENTENNIAL PARADE. Film star Ginger Rogers, who rose to fame as Fred Astaire's dance partner, leads Monterey's Centennial Parade on September 3, 1949. Miss Rogers was one of many celebrities on hand for the event. Later in the evening, she and California governor Earl Warren started the first dance at a ball given at the old Hotel Del Monte. (George T. Esaki, photographer; Jean Esaki, donor; Shades of Monterey II Collection, No. 7171.)

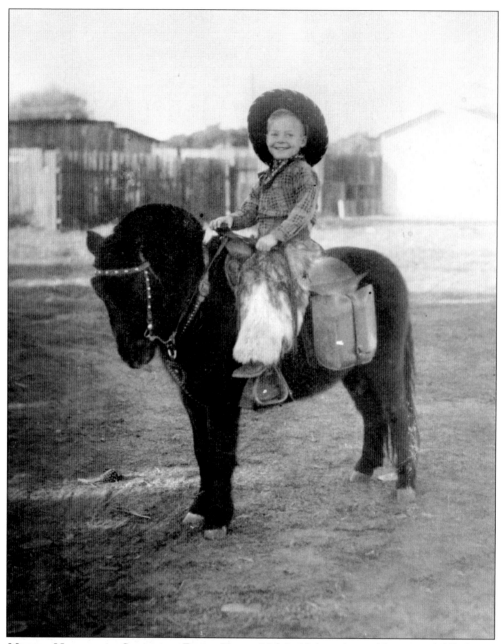

MELVIN NELSON ON SHETLAND PONY. Young Melvin Nelson sits astride every child's dream vehicle, *c.* 1946. Melvin was born at the Presidio of Monterey in 1943. (Melvin Nelson, donor; Shades of Monterey Collection, No. 7072.)

GETTING AROUND

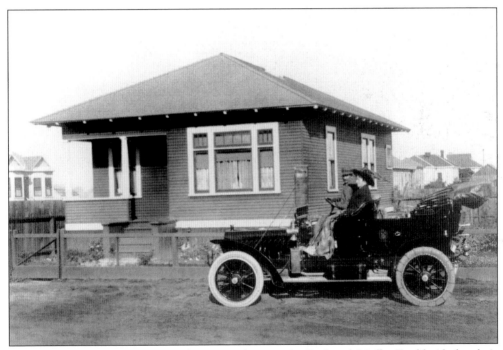

FRED AND MOLLY GOULD. In this 1909 photograph, Fred and Molly Gould ride by their home at 1109 Eighth Street in an auto borrowed from the Hotel Del Monte. Fred was a driver of Associated Oil Company and later a chauffeur. Fred was the son of George S. Gould, justice of the peace and postmaster of Imusdale, in southern Monterey County. The Goulds moved to Monterey in 1896. (Muriel Pyburn, donor; Shades of Monterey Collection, No. 6906.)

BEN GRAHAM ON TRICYCLE. The usually dignified Ben Graham enjoys a playful moment on his child's riding toy in the 1940s. Ben was the building and plumbing inspector for the City of Monterey. (Ann Quattlebaum, donor; Shades of Monterey Collection, No. 6828.)

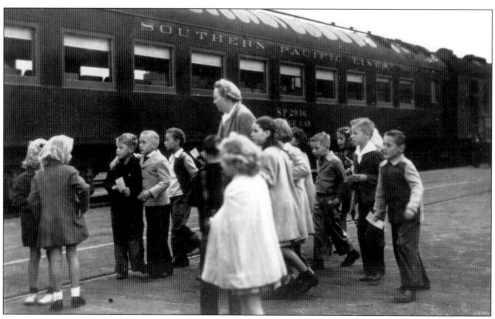

FIELD TRIP ON THE TRAIN. Del Monte Elementary School teacher Doris (Stine) Manning waits with her class for their return trip to Monterey at the Southern Pacific turnaround near Asilomar. The class was on a field trip to Pacific Grove in this 1950 photograph. (Evelyn Crumpley, donor; Shades of Monterey II Collection, No. 6545.)

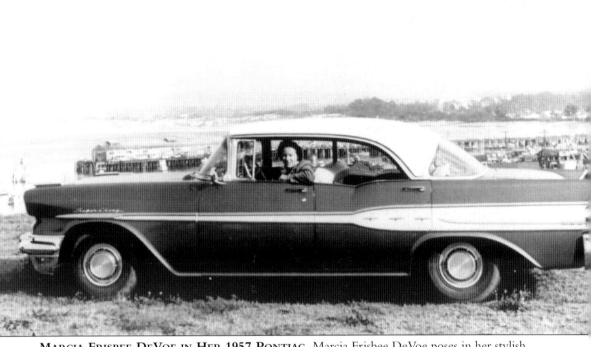

MARCIA FRISBEE DEVOE IN HER 1957 PONTIAC. Marcia Frisbee DeVoe poses in her stylish 1957 Pontiac (the same model then used by the California Highway Patrol) on Presidio hill overlooking Monterey Harbor. In the distance can be seen Monterey's Municipal Wharf, Fisherman's Wharf (to the right), and the Monterey shoreline. (Marcia DeVoe, donor; Photo No. 3711.)

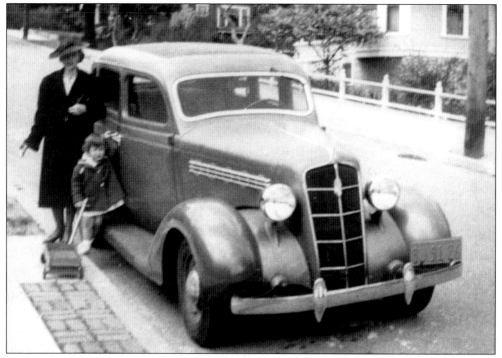

FAY AND ANN GRAHAM. Fay (née Baugh) Graham and her daughter Ann pose in front of their home at 967 Harrison Street, *c.* 1940. Fay was married to Ben Graham and was very active in the Women's Civic Club. (Ann Quattlebaum, donor; Shades of Monterey Collection, No. 6817.)

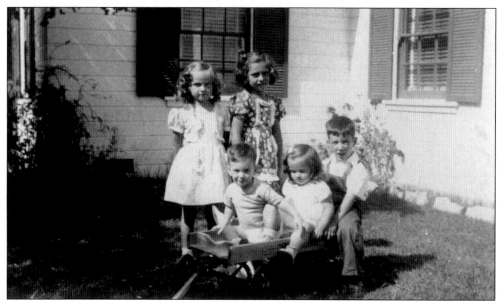

PREGO GIRLS AND DARLING BOYS. From left to right are the three Prego sisters, Ann, Nancy, and Linda, and brothers Jim and Bruce Darling. The neighborhood friends sit in a wagon on the lawn in front of the Darling's home at 35 Via Del Pinarse. This photograph was taken on July 7, 1945. (Ann Prego, donor; Shades of Monterey Collection, No. 6418.)

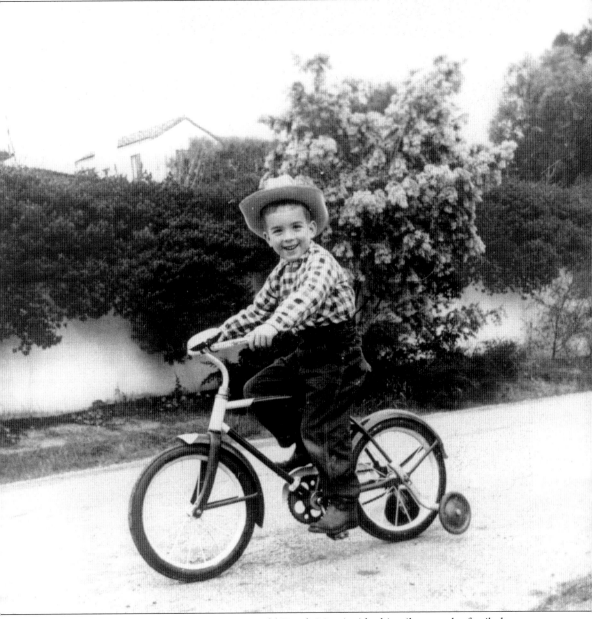

DEREK MORRIS ON TRICYCLE. Five-year-old Derek Morris rides his trike near the family home on Alameda Street, 1950s. (Meg Morris, donor; Shades of Monterey Collection, No. 6834.)

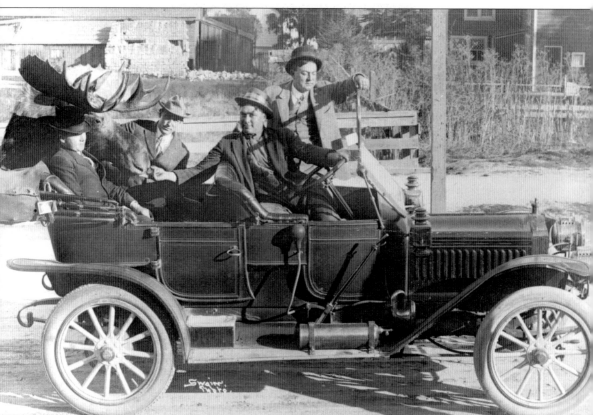

CHARLES MCFADDEN AND FRIENDS. Charles McFadden transports a moose head and friends in his Maxwell car in 1915, near his sister Ruth Ellen's home on Larkin Street. Charles was married in 1912 to Della Stanley (née Nally), a young widow who was born and raised in County Galway, Ireland, and was living with relatives in Watsonville when they met. The McFadden family migrated to the United States from Manitoba, Canada, in the 1880s, but whether the moose head came with them is an unanswered question. (Marge Turnbull, donor; Shades of Monterey Collection, No. 6654.)

THE GARTSHORE GIRLS. Jane Gartshore, in a new dress sent from Glasgow, Scotland, by her Aunt Euphemia, pushes a buggy containing her baby sister Bonnie. The other girl is Jane and Bonnie's sister, Mary Lou. This photograph was taken near the family's New Monterey home in 1925. (Bonnie Gartshore, donor; Shades of Monterey II Collection, No. 6154.)

MARY BELL. Posing here on a police scooter in 1965, Mary Bell became Monterey's first sworn policewoman in 1957. She reports that she was treated well by her fellow officers. (Mary Bell, donor; Shades of Monterey Collection, No. 7221.)

MYRON AND MARY OLIVER. Myron Oliver and his mother prepare for a Monterey bicycle excursion in back of Oliver's art store, *c.* 1895. Myron Oliver also remembered, as a boy, walking to school on wooden sidewalks. "Living close to the waterfront, we fished every chance we got." (J.K. Oliver, photographer; Oliver Collection, No. 4451.)

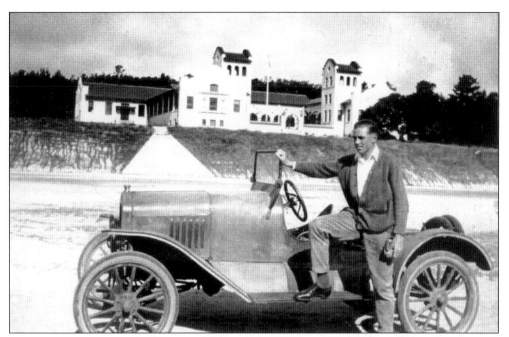

LEONARD WILLIAMS WITH ROADSTER. Leonard Williams is pictured with a roadster in front of Monterey High School in the 1920s. (Marcia DeVoe, donor: Historical Photo No. 3724.)

"LAUGHING JACK ASS." Unidentified friends of Charles McFadden are photographed here in a mule driven wagon in the 1920s, probably at the Presidio. Charles worked as a mule team driver hauling the first load of brush and trees off the Presidio grounds down to a gully off Lighthouse Avenue. While working for T.A. Work's lumber mill, he also hauled lumber to the Presidio for construction of the headquarters, hospital, and officers' mess. (Marge Turnbull, donor; Shades of Monterey Collection, No. 6661.)

TOURING THE WHARF. Cyclists Ruby Curtis, Michael Redmond, and wife Carolyn Richmond tour the Wharf before heading south to Big Sur in 1969. Michael and Carolyn left Chicago on their bikes, pedaling the 2,500 miles to Monterey. Ruby (Carolyn's mother) flew to San Francisco in order to join the California tour. (MacDougall King, photographer; Harbick Collection.)

ALPHONSE AND MARIE ELSEN. Siblings Alphonse and Marie Elsen ride tricycles in the yard of the family home on Carmelito Circle, *c.* 1921. They were the children of confectioner and candy store owner Edward Elsen and his wife, Philomena. Alphonse, known as "Al," worked for the *Monterey Peninsula Herald* as their circulation manager for 41 years, beginning in 1941 when the paper sold for a nickel and newsboys hawked the publication on the streets. (Marie McCrary, donor; Shades of Monterey Collection, No. 6454.)

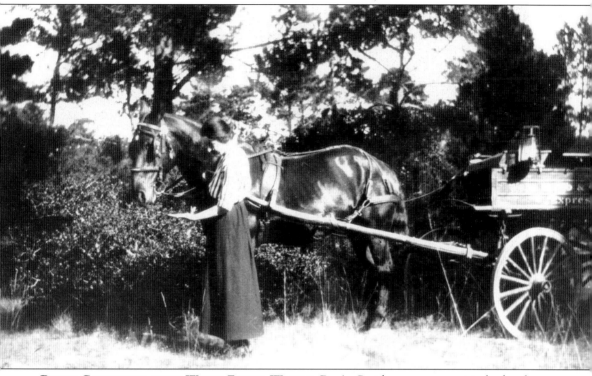

BESSIE GARTSHORE WITH WELLS FARGO WAGON. Bessie Gartshore pauses next to husband John's Wells Fargo Express wagon, *c.* 1919. He made deliveries all over Monterey in this horse-drawn wagon. (Bonnie Gartshore, donor; Shades of Monterey Collection, No. 6200.)

THE 11TH CAVALRY. The 11th Cavalry, pictured here in the 1920s, was at home in the Presidio of Monterey during the period between World War I and World War II. (Marge Turnbull, donor; Shades of Monterey Collection, No. 6662.)

HORSE-DRAWN BUGGY AT DEL MONTE HOTEL. Frank Gilbert Anthony, a watchman at the Hotel Del Monte, speaks with Maj. Gen. Shafter (driving the buggy) on the hotel grounds in the 1890s. Born in 1836, Anthony was a pioneer who first visited California by sailing around Cape Horn from Connecticut at the age of 14 on one of his father's ships. He made other trips to the West in the 1860s with the California Geological Survey. He settled for a time in Iowa, married there, and in 1884 brought his wife and children to Monterey, where they took up residence on Decatur Street, near the First Brick House. (Jan MacLean Jones, donor; Shades of Monterey II, No. 6122.)

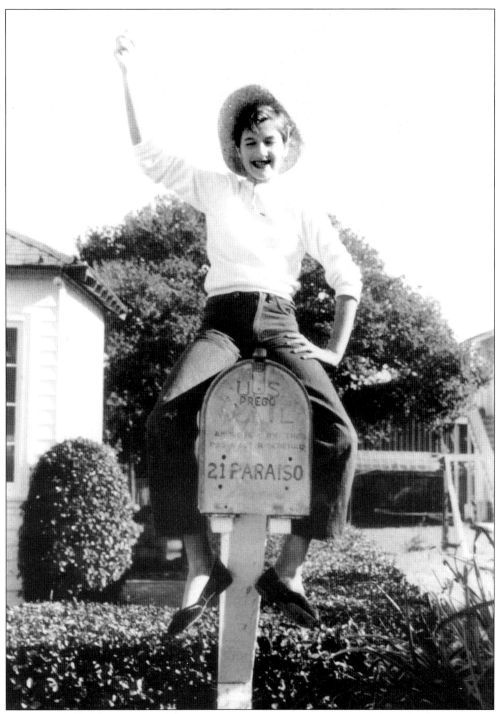

RIDE 'EM COWGIRL. The mailbox at 21 Via Paraiso makes a great "horsey" for the Prego family's youngest daughter, Linda, during a game of "cowboys" with the neighborhood kids. This photograph is dated January 1955. (Linda Thorpe, donor; Shades of Monterey II Collection, No. 6511.)

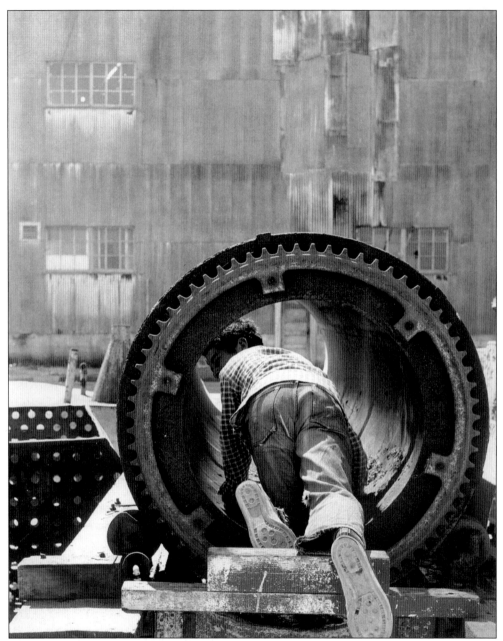

HIDE AND SEEK, CANNERY ROW STYLE. A discarded pipe from the heyday of Cannery Row offers the perfect place for hide and seek in this 1959 image. (Miles Midloch, photographer; Harbick Collection.)

KID STUFF

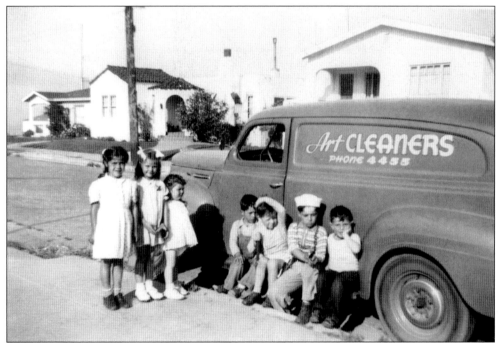

KIDS AND ART CLEANERS' TRUCK. Neighborhood kids gather around Art Cleaners delivery truck, parked in the 200 block of Watson Street in the early 1940s. The girl in the middle is Maggie Branson. Maggie's family moved to Monterey in the 1930s. The children grew up and Art Cleaners is no longer in operation, but the neighborhood seen in the background has changed little since the time this photo was taken. (Maggie Branson Wenzel, donor; Shades of Monterey Collection, No. 6015.)

ANGELO ANASTASIA JR. OUTFITTED FOR FOOTBALL. Angelo Jr., seen here with his new football gear on Christmas morning 1954, grew up to be a real estate broker who now owns the home at 888 Pacific Street where his grandparents Joseph and Jennie Anastasia lived during Angelo's childhood. (Angela McCurry, donor; Shades of Monterey, No. 6246.)

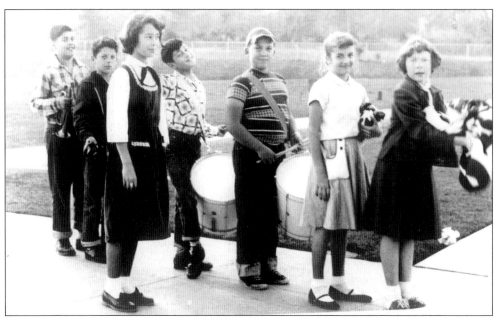

FLAG DUTY AT MONTE VISTA SCHOOL. A daily ritual at Monte Vista School in 1954 was raising the flag each morning. George Dovolis played the trumpet and Tommy Mercurio and Frank Davi played drums. From left to right are George Dovolis, Vince Cardinale, Carol Ann Rhodes, Tommy Mercurio, Frank Davi, Linda Prego, and Susan Phinney. (Linda Thorpe, donor; Shades of Monterey II Collection, No. 6500.)

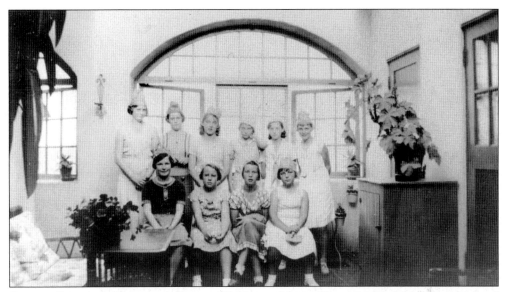

SHERYL SMYTHE'S BIRTHDAY PARTY. Children celebrate Sheryl Smythe's birthday in one of the rooms on the second floor of the State Theatre, *c.* 1931. Pictured, from left to right, are (front row) Edith James, Carmelina Burns, unidentified, and Catherine Sandholt; (back row) Jean Welker, Jane Vincent, Juanita Flagg, Sheryl Smythe, Joan Clegg, and Phyllis Dorsey. The State Theatre opened in 1926 as the Golden State Theatre, a 1,600-seat movie palace designed to give the impression of being inside a Spanish courtyard. (Edith James Karas, donor; Shades of Monterey Collection, No. 6012.)

CHILDREN IN ITALIAN COSTUMES. Children dressed in costumes view the festivities from a painted donkey cart from Italy during the 1970 Santa Rosalia Festival. (Patricia Rowedder, photographer; Harbick Collection.)

EASTER SUNDAY BEST. Carmen Castro and her brother Frank Castro Jr. show off their baskets on Easter Sunday, *c.* 1936. The siblings are the children of Elizabeth (née Shiffer) and Frank Castro Sr. (Jean Cordero, donor; Shades of Monterey Collection No. 6214.)

SPRING PLAY AT DEL MONTE SCHOOL. The "bees" in costume for the annual spring play at Del Monte School, *c.* 1930, include, from left to right, Charles Benson, Robert Hilburn, "Shorty" Sherwood Karstad, Donald Pitcher, Billy Puget, Dudley Rose, Sydney Manning, and Billy Pugh. (Evelyn Crumpley, donor; Shades of Monterey II, No. 6549.)

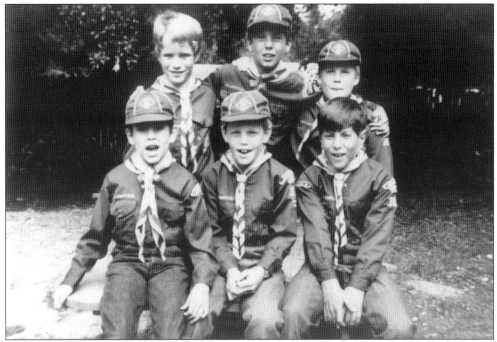

CUB SCOUTS. Pictured, from left to right, are members of Cub Scout Den No. 4 from Monte Vista School in 1970: (front row) Jimmy Stracuzzi, Bill Hudson, and Sal Tringali; (back row) Matt Tammen, David Russo, and Ed Broome. Bill is the son of Jay and Kip Hudson, who came to Monterey in 1967, where Jay later became the chief administrator of Community Hospital of the Monterey Peninsula. (Kip Hudson, donor; Shades of Monterey II Collection, No. 7200.)

ALL ABOARD. For 50 years children have been riding the big locomotive at Dennis the Menace Playground in El Estero Park. Charlie Martin waves from the engineer's seat in this 1956 photograph. While Dennis the Menace cartoon creator Hank Ketcham was working on plans for the new playground, he decided to ask Southern Pacific Railroad to donate the big train engine as a play structure. "Do you realize this locomotive is worth $10,000?" they asked. Ketcham responded, "Yeah, and it would be worth sixty times that in public relations." Children have been climbing aboard ever since. (Dolores Martin, donor; Shades of Monterey II Collection, No. 7186.)

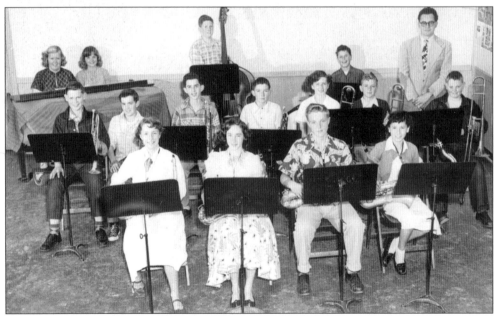

WALTER COLTON SCHOOL BAND, 1951. The young musicians, from left to right, are (front row) Pat McDonald, Audrey Williams, and (?) Anderson; (back row) Doris Mashmeyer and Maggie Branson (at the piano), Breck Tostevin, and Tommy Nielson. (Maggie Branson Wenzel, donor; Shades of Monterey II Collection, 6021.)

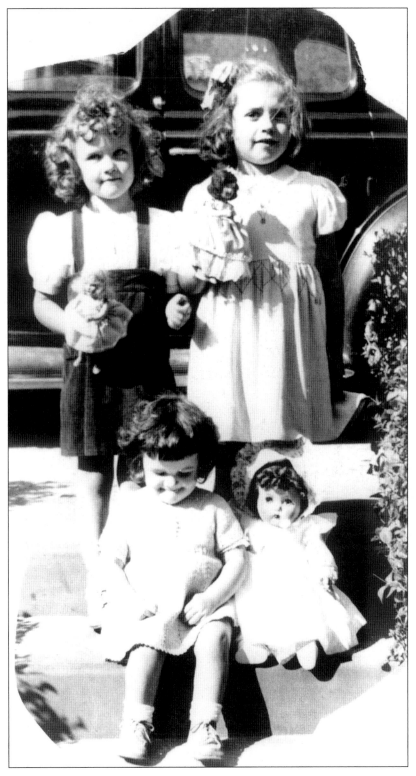

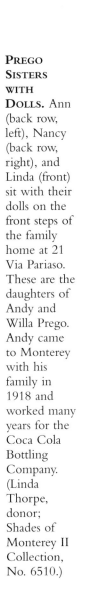

PREGO SISTERS WITH DOLLS. Ann (back row, left), Nancy (back row, right), and Linda (front) sit with their dolls on the front steps of the family home at 21 Via Pariaso. These are the daughters of Andy and Willa Prego. Andy came to Monterey with his family in 1918 and worked many years for the Coca Cola Bottling Company. (Linda Thorpe, donor; Shades of Monterey II Collection, No. 6510.)

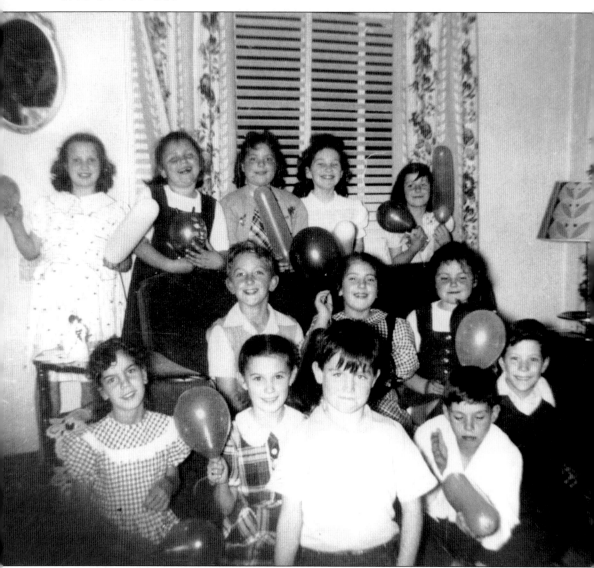

Birthday Party for Rosemary Cardinale. Children celebrate Rosemary Cardinale's birthday at the Cardinale home, *c.* 1949. From left to right are (front row) Theresa Yeme, Francesca Garcia, Dennis Moriarity, Michael Balesteri, and Vince Colletto; (middle row) Peter Tarantino, Christine Randazzo, and Francesca Davi; (back row) Mary Ann Da Vigo, Marguerite Davi, Carolyn Loero, birthday girl Rosemary Cardinale, and Kathleen Moriarity. (Carolyn Loero Carlson, donor; Shades of Monterey II, No. 6932.)

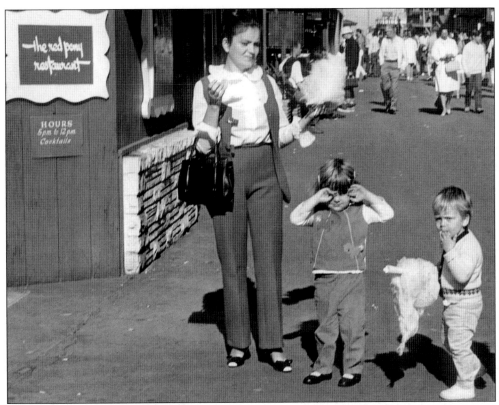

COTTON CANDY ON THE WHARF. Elfi Vandaisen, her daughter Sheila, and son Ronnie sample the sweet treat on Fisherman's Wharf in December 1969. (MacDougall King, photographer; Harbick Collection.)

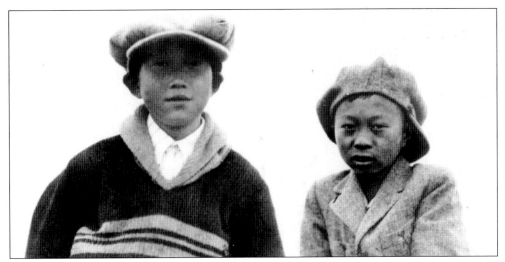

GEORGE ESAKI AND FRIEND, 1922. George's parents emigrated from Japan in the early 1900s and worked in the fishing and abalone business. George, pictured on the left, grew up to be a professional photographer and an important leader in the Japanese-American community. (George T. Esaki, photographer; Jean Esaki, donor; Shades of Monterey II, No. 7131.)

DOLORES MARTIN'S CHRISTMAS, 1956. Pictured at the family home at 1000 Prescott Avenue, Dolores and her family, whose Basque ancestors came from Spain via Mexico, have lived on the Monterey Peninsula for over a century and a half. (Dolores Martin, donor; Shades of Monterey II, No. 7188.)

RUTH WENNEBERG. Monterey Public Library's first bookmobile librarian Ruth Wenneberg helps a boy with his reading while others look on in this 1956 photograph. (George T. Smith, photographer; Historic Photo No. 4086.)

CURTIS CRUMPLEY, BOY SCOUT. Eleven-year-old Curtis Crumply, posing in his Boy Scout uniform in 1953, was kicked out of the group about one week later because he didn't attend an activity. He grew up to be a Coast Guard commander. (Evelyn Crumpley, donor; Shades of Monterey II Collection, No. 6553.)

ALFRED AND GILBERTO SERNA. Brothers Alfred and Gilberto Serna of Salinas and their dog Duchess sample shrimp cocktails on Fisherman's Wharf in this 1969 photograph. (Harbick Collection.)

ANASTASIA CHILDREN AT PLAY. Siblings Millie on rocking horse and Angelo Jr. on tricycle are in the backyard of the Anastasia family's home on Newton Street in New Monterey. Millie's full name was Matilda Rose Marie Anastasia, while Angelo was given the middle name "Victor" in honor of his father's friend, who was affiliated with the radio and phonograph company RCA Victor. (Angela McCurry, donor; Shades of Monterey, No. 6953.)

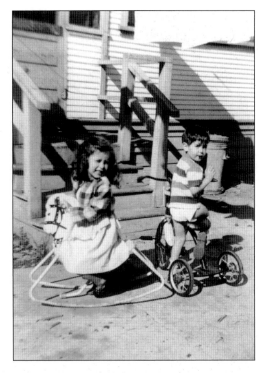

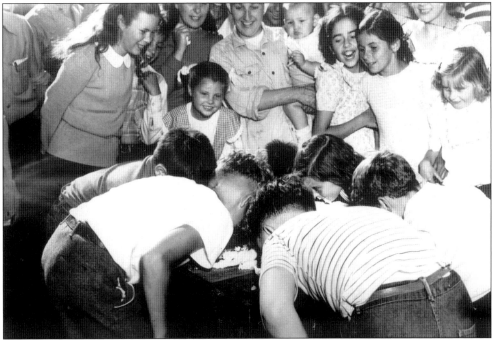

PIE-EATING CONTEST. Children dive into a pie-eating contest at an Elks Club picnic held at Monterey Fairgrounds, *c.* 1947. Maggie Branson is the girl in the gingham dress, and the girl at the far right is Lorraine Lee. (Maggie Branson Wenzel, donor; Shades of Monterey Collection, No. 6519.)

VISIT WITH SANTA. Deborah Sue Elmore, niece of Yvonne (née Des Cormier) Ashmore, visits with a Monterey department store Santa in 1956. The Des Cormier family came to California on vacation in 1940 and decided to stay. (Yvonne Ashmore, donor; Shades of Monterey Collection, No. 6414.)

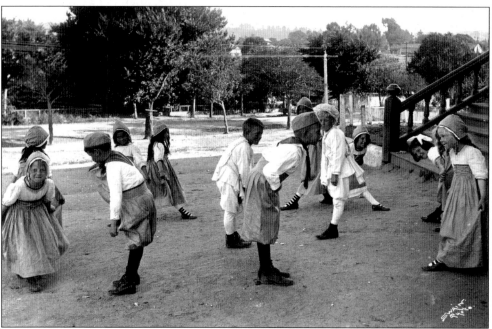

FOLK DANCE. Dressed in costume, these children perform folk dances at Monterey's grammar school about 1899. (F.E. Swain, photographer; Oliver Collection, No. 4423.)

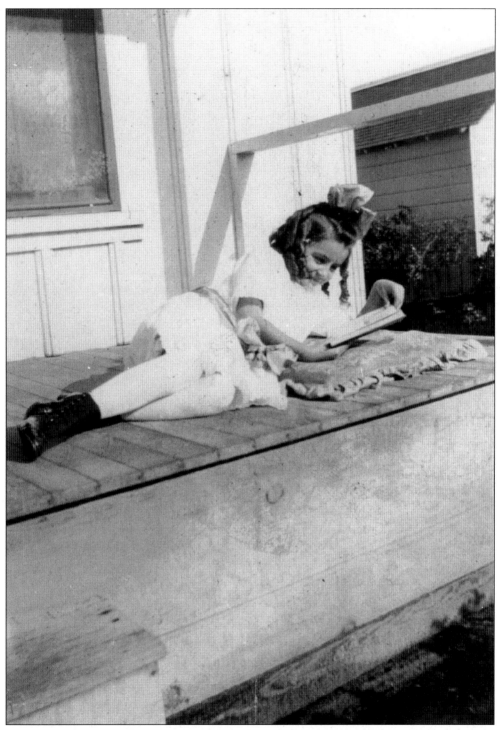

DODY WILSON. Dody Wilson reads on the front porch sometime between 1910 and 1916. Dody is the daughter of Jennie "Juanita" Piazzoni Wilson and the granddaughter of Luigi Piazzoni and Tomasa Manjares. (Jean Cordero, donor; Shades of Monterey Collection, No. 6219.)

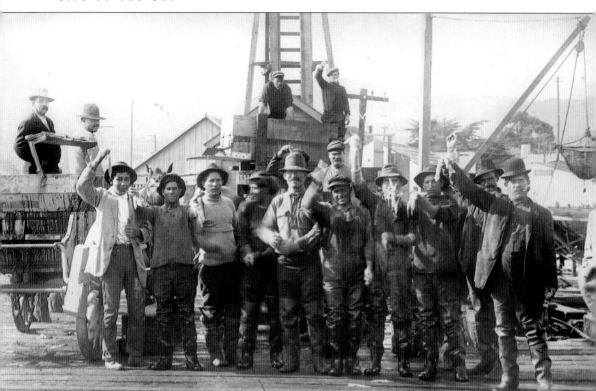

SQUID FISHERMEN. Squid fishermen display samples of their catch on the old Fisherman's Wharf about 1920. Long a traditional food for Italians and Chinese, squid eventually gained acceptance as standard fare on many restaurant menus. Squid fishing did not fully develop until Italian-American fishermen began competing with Chinese fishermen on Monterey Bay. The Chinese had fished for squid at night while the Italians fished during the day. But in 1924, enterprising Won Yee, owner of the Wing Chong grocery on Cannery Row, negotiated to buy fresh squid from Sicilian fishermen and then dried the squid at Tarpy Flats for export to China. (Historic Photo No. 4146.)

BY THE BAY

MANNING FAMILY ON THE BEACH. Doris (née Stine) Manning, center, poses with her daughter Evelyn and son Sydney on the Monterey beach near the train station in 1936. Doris was involved in local education, first as a teacher and later as a member of the Monterey County Office of Education and the county president of the Parent-Teacher Association. Years later Doris's granddaughters would follow her path, one becoming a school nurse and the other a school principal. In the distance is the Del Monte Bath House. In 1879, champion swimmer William Daily reported, "I consider the beach here the finest on the Pacific Coast." (Evelyn Manning Crumpley, donor; Shades of Monterey II Collection, No. 6558.)

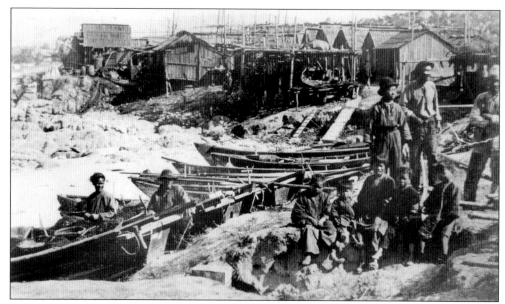

CHINESE FISHING VILLAGE. By the early 1870s, the Monterey Peninsula had become the focus of the Chinese fishing industry. The largest fishing village was located at the cove at Cabrillo Point, now the home of the Hopkins Marine Station. This rare 1875 photograph shows residents, the village, boats, and drying racks. The village was unique for the period in the number of large families, including women and children, who lived there. The earliest mention of Chinese people living on the cove is 1857. (Historic Photo No. 1486.)

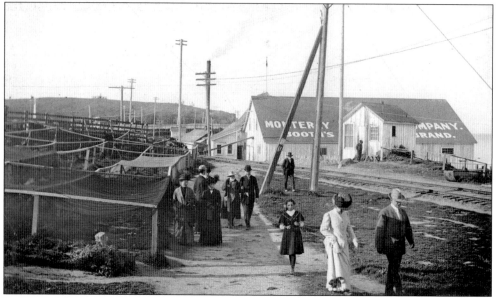

HOTEL DEL MONTE GUESTS. Guests at the Hotel del Monte stroll past net-drying racks after a visit to Frank Booth's new sardine and salmon cannery near Fisherman's Wharf, *c.* 1904. Another popular attraction during this era was the "Wheel of Sardine," a circular floating pen that Booth used to keep the sardines fresh. People and, especially, sea lions and gulls watched, fascinated by the silver whirl of fish. (Historical Photo No. 586.)

MIKE LUCIDO. Skipper of the purse seiner *Sea Boy*, Mike Lucido still expertly mended nets in 1966. Born in a small Sicilian fishing village in 1890, Mike started fishing at age 13. He arrived in the United States in 1920 and settled in Monterey. Mike told the story of how, on a late January night in 1943, he spotted a bright "silver harvest"—a very large school of sardines—perhaps 180 tons. He circled with the boat so the school of fish moved into the center of the net. Setting low in the water from the heavy load, he eased the boat through a big swell back to the canneries, which came alive. Smoke rose from the boiler stacks. Almost 75 years old in this photo, Mike was often seen playing cards outside the fisherman's Union Hall or involved in a game of bocce ball across from the old Custom House. (Harbick Collection.)

SKINNY-DIPPERS AND SWIMMERS. Beachgoers enjoy activities at Monterey's beach about 1889. (C.W.J. Johnson, photographer; Historical Photo No. 3244.)

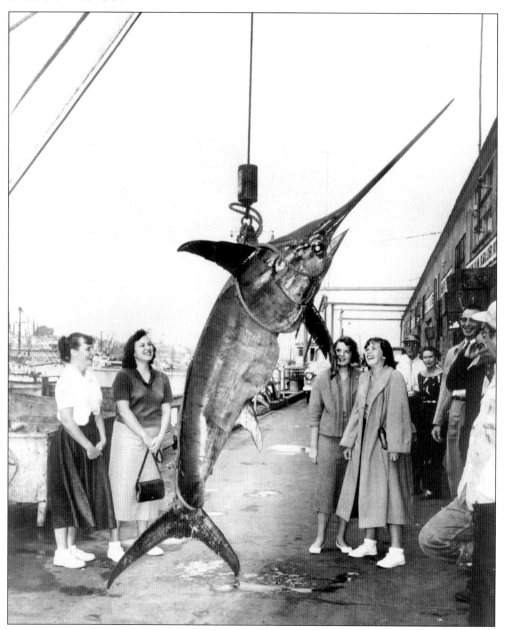

BIG CATCH. From left to right, teenagers Phyllis Peters, Mary Ann DaVigo, Carolyn Loero Carlsen, and Irena Maceria get a close up look at a huge swordfish caught and put on display on Wharf #2. This photograph is dated October 2, 1956. (William Morgan, photographer; Gary Carlsen, donor; Shades of Monterey II Collection, No. 6931.)

MILLIE, MIKE, AND CORA PAREDES. Mike Paredes with his wife, Millie (left), and his sister Cora are pictured at Fisherman's Wharf, *c.* 1938. Mike and Millie came to Monterey from Arizona in the 1930s, bringing with them his orphaned sister-in-law Ruth Web. A few years later, Ruth married Mike's friend, Angelo Anastasia. (Angela McCurry, donor; Shades of Monterey Collection, No. 6249.)

ANGELO ANASTASIA ON THE BEACH. Two unidentified young ladies in swings enjoy Angelo Anastasia's gymnastic talents on Del Monte Beach in this 1941 image. Angelo was the son of Joseph and Jennie Anastasia, owners of Anastasia's Fish Market on the Wharf. Hardworking, with a sharp eye for new opportunities, Angelo made several career changes during his lifetime. He worked for the Monterey Ice Company, purchased Terry's Barbecue where his children recall plucking chickens and putting them on spits, and later sold real estate. Angelo devised a number of inventions and held patents on several gadgets including a seat belt and a razor. (Angela McCurry, donor; Shades of Monterey II Collection, No. 6241.)

OLD MAN OF THE SEA. A lone fisherman is seen with his day's catch in a skiff on the bay in November 1940. (William L. Morgan, photographer; MO481-K.)

BIG SARDINE CATCH. Monterey's fishermen unload a big sardine catch from a lighter (barge) at Booth's cannery dock on October 10, 1937. It could take a crew from four to five hours to unload after fishing all night. Booth's offered the only cannery with dockside loading. (Morgan Collection, Photo MO293B.)

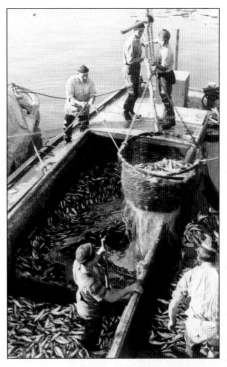

BALANCING ACT. Carrie May Ross and her husband, David, attempt a balancing act on the teeter totter at the Hotel del Monte. The Rosses of Copperopolis, California, vacationed in Monterey in 1905. Monterey continues to draw visitors, and tourism remains a major industry in the area. (Calaveras County Historical Society, Drew Family Album; Historic Photo No. 6250.)

151

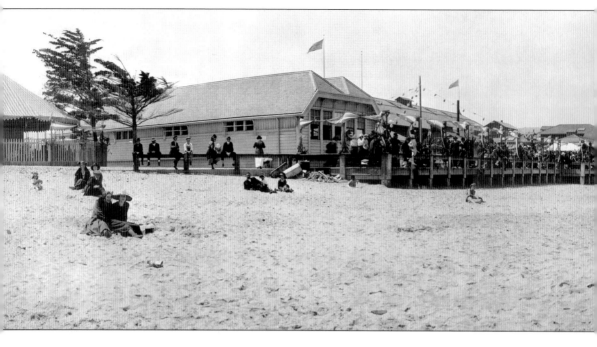

THE DEL MONTE BATH PAVILION. Visitors at the Del Monte Bathhouse cheer the arrival of the Navy's Pacific Fleet to Monterey Bay in August 1919. The Del Monte Bath Pavilion was one of the fashionable spots to bathe, either in the swimming pool or in the waters of Monterey Bay. The bathhouse was located on the beach, about a quarter mile from the "Queen of American water-places," the luxurious Hotel del Monte. The "baths of Monterey" were described in 1887

as "the most noteworthy preparation for health and pleasure," which, "without any fabulous medicinal quality whatever, have become famous as baths that heal." The hotel's bathhouse, a glass-covered building, contained cold and warm baths, as well as a pool slide. (A.C. Heidrick, photographer; Panorama Collection, Photo No. 1841.)

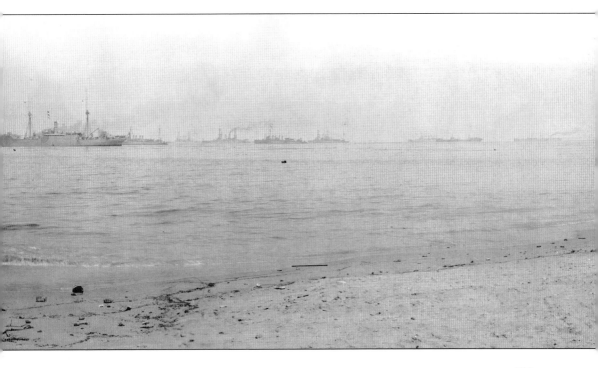

SPORT FISHING ON MONTEREY BAY, 1959. A favorite local activity is a day of sport fishing from one of several commercial party boats. (Harbick Collection.)

THE SCOOP ON SMELT. Fish have not always been hard to catch in Monterey Bay. Many times the waters have miraculously boiled with smelt, herring, hake, cod, or anchovy. In this 1902 photograph, men scoop up the run of smelt on the beach and shallow waters near the Old Custom House. In 1863, it was reported that "in many places they still lie from twelve to fourteen inches thick on the beach, and out in the bay may be found acres of them so thick that whalers find difficulty in getting through with their boats." (J.K. Oliver, photographer; Oliver Collection, No. 4468.)

ON THE BEACH. Pictured here in 1944, from left to right, are Lillian (McKeaver) Johanson, Richard Johansen, and Edna (McKeaver) Goldsworthy. Sisters Edna and Lillian were born in Monterey and grew up on Clay Street. Lillian married Richard Johansen, a salesman for Tice Electrical, and Edna married Clarence Goldsworthy, general manager of the California Water and Telephone Company in Monterey. (Ann Todd, donor; Shades of Monterey Collection, No. 6439.)

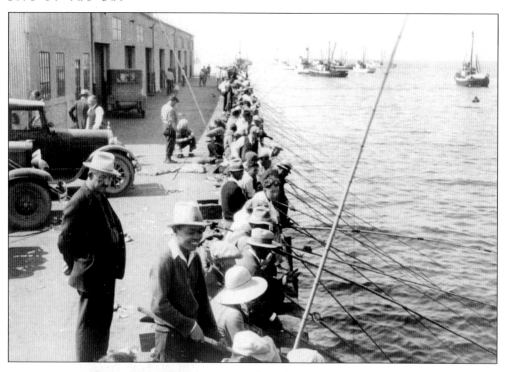

GONE FISHING. Locals enjoy fishing off the Municipal Wharf in the late 1930s. (Gary Carlsen, donor; Shades of Monterey Collection, No. 6402.)

FRANK RODRIGUEZ. Frank Rodriguez shows off a 52-pound salmon on Fisherman's Wharf during the summer of 1952. (Lee Blaisdell, photographer; Jean Rodriguez, donor; Shades of Monterey II Collection, No. 6352.)

EDITH AND SAM KARAS. These newlyweds pose on the Wharf in 1944, and the Lighthouse Avenue curve and El Castillo site can be seen in the background. Edie, a Monterey native, was born into the old and prominent James family. Sam's family emigrated from Greece around 1918. The couple met in 1943 when Edie, a Stanford coed, was home on summer break. A girlfriend introduced her to young Army lieutenant Sam Karas, who was on duty at Fort Ord. They married the following year. Edie distinguished herself as a college instructor and in a wide range of community service activities. Sam went into the meat business and for 50 years immersed himself in local political leadership. He served in many appointed and elected capacities, including the Monterey County Board of Supervisors. Sam and Edie raised three daughters, Penny, Judy, and Rachel. (Edie Karas, donor; Shades of Monterey II Collection, No. 7205.)

FISHERMAN'S WHARF. Tourists visit the shops and restaurants on Fisherman's Wharf at Monterey in May 1958. (Lee Blaisdell, photographer; Historic Photo No. 4004.)

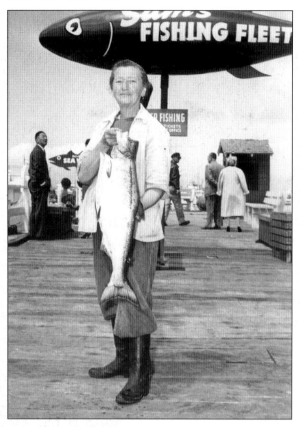

BESSIE OSTROW. A steady customer of Sam's Fishing Fleet for 14 years, Bessie Ostrow shows her 12-pound catch during the Salmon Fishing Derby in June 1957. Bessie caught her salmon on board the boat *Dolphin,* skippered by John Poggi. The annual derby offered such prizes as cash awards, boat motors, or even a boat for the men who caught the largest fish. Among the prizes for women was a toaster. (Harbick Collection.)

SHIPS AND SHIPWRECKS. Ships and shipwrecks have been a constant reminder of the formidable power of wind and sea on the Monterey coast. On December 14, 1943, a "northeaster" churned and blew across the bay, pushing the sardine fleet onto the shore where many boats were wrecked. Here, local residents, including a father and child, watch the destruction from the Municipal Wharf. (Historic Photo No. 1629.)

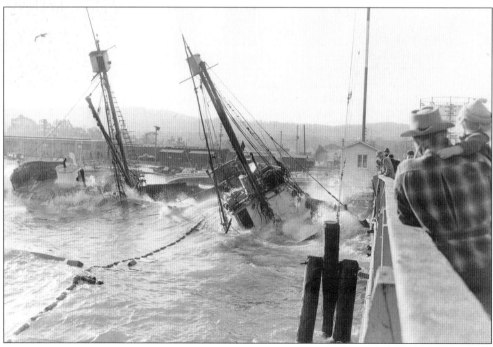

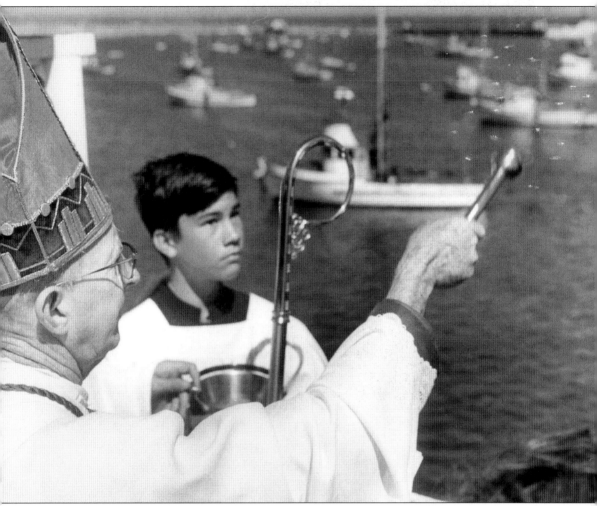

BLESSING THE FLEET. Bishop Harry Clench blesses the fishing fleet of Monterey from the end of Fisherman's Wharf in September 1970. Montereyans, especially Sicilian Montereyans, celebrate the feast day of the Sicilian saint and protector of fishermen, Santa Rosalia, every year. (Patricia Rowedder, photographer; Harbick Collection.)

JOHN SHEPPARD ON THE BEACH. Young John Sheppard plays with an inner tube on Del Monte Beach, *c.* 1960. John's aunt was lifelong Monterey resident, journalist, historian, poet, and teacher Bonnie Gartshore. (Bonnie Gartshore, donor; Shades of Monterey II Collection, No. 6155.)